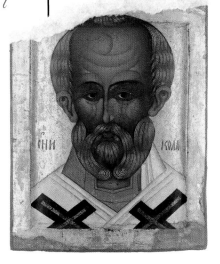

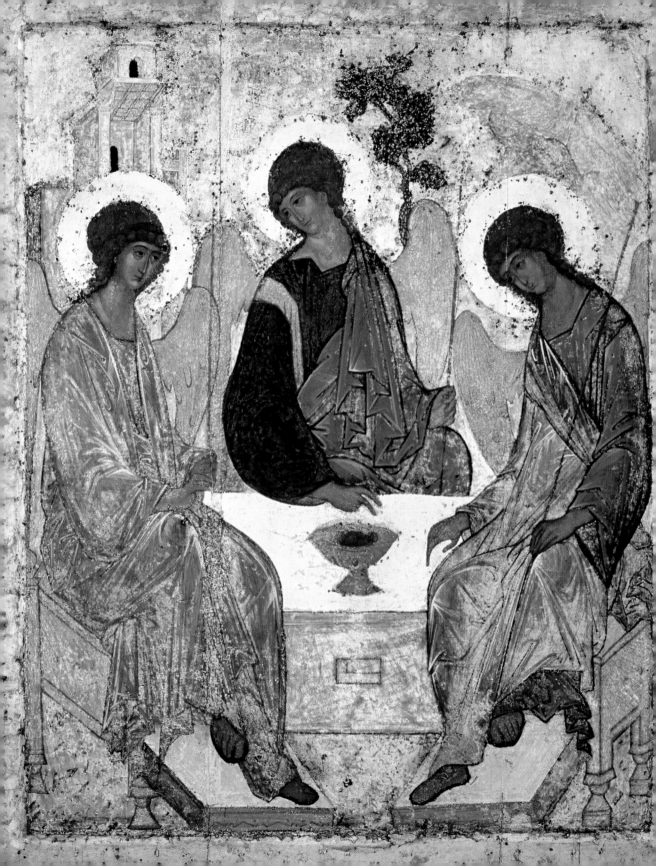

icons

EVA HAUSTEIN-BARTSCH
NORBERT WOLF (ED.)

IKONEN-MUSEUM, RECKLINGHAUSEN

TASCHEN

HONG KONG KÖLN LONDON LOS ANGELES MADRID PARIS TOKYO

contents

Images of the Divine

The Miraculous Icon

In the West, the central role played by the icon in the Orthodox Church and especially in Russia has often met with incomprehension. The German scholar Adam Olearius (1599–1671) was amazed at various practices he observed on his Travels through Muscovy and Persia in 1633–1639: "They attribute a power to the pictures as though these could help to bring about something particular. They will dunk a picture into their beer, for example, when they are brewing, in order that the brew may succeed. They are really afraid of them, as though there were actually something divine in them. When they wish to pursue the pleasures of the flesh in the presence of an icon, they first cover it with a cloth." He goes on: "That the simple common folk ascribe great power to images can also be seen in the fact that when there was a fire, a Russian held up his St Nicholas image to the flames and prayed for it to quench the conflagration. When no help came […], he threw the image impatiently into the fire, saying: If you don't want to help us, you'll have to help yourself […]"

These customs lived on into the 20th century, indeed into atheist Soviet times, as reported in the memoirs of the German diplomat Hans von Herwarth. He reported an experience during the Second World War: "We had just taken a village, and were resting in the village street, when suddenly we came under Soviet artillery fire. The thatched farmhouses went up in flames, which were fanned by a strong wind. Soon we were faced by a conflagration which we could no longer combat. When we evacuated the village, we saw the peasants climbing on to the roofs of their still-burning houses, holding up their icons to heaven, and praying in loud voices for the wind to die down and for their houses to be spared." For many centuries, icons had been credited with the power to work miracles.

In most cases, it was icons of the Mother of God with the Christchild to which the healing of the blind and the lame, the possessed and the feverish was attributed, along with the liberation of whole regions from epidemics. They were also credited with bringing victory over enemy armies and raising sieges.

Thus the highly venerated icon of the Mother of God Hodegetria (pointer of the way), which had been painted, according to legend, by St Luke the Evangelist, became the patron of Constantinople. It is said to have preserved the Byzantine capital several times from enemy conquest (p. 7), and the Byzantine emperors prayed in front of the icon before taking any major decision or embarking on any military campaign. The *Mother of God of the Miracle of Novgorod* is said to have

313 — Edict of Milan: Christianity is accorded equal rights with other religions in the Roman Empire

325 — First Ecumenical Council is held at Nicaea

330 — Emperor Constantine the Great founds the

> **"we stipulate that the holy icons of our Lord Jesus christ be venerated and shown the same honour as is shown to the books with the Holy Gospels. For as we all gain salvation through the words of the latter, so all, the knowing and the ignorant, likewise find spiritual profit through the pictorial effect of the colours."**
>
> From the proceedings of the 8th Ecumenical Council in 869/870

1. SIEGE OF CONSTANTINOPLE (DETAIL)
1537, fresco
Moldovita monastery (Romania), South exterior wall

1

decided the battle between the forces of Suzdal under Prince Andrei Bogolyubsky against the city of Novgorod in the latter's favour on 25 February 1170. For three days and three nights, Archbishop Ioann had prayed for the salvation of the city in St Sophia Cathedral, when he was told by a voice from the icon of Christ to take the icon of the Mother of God from the Church of the Redeemer in Elijah Street to the city walls. Here it was stood in place by the archbishop. The chronicle reports that the enemies showered the city "with arrows like a heavy shower of rain". When one arrow struck the icon, its front side, with the depiction of the Mother of God, turned away from the enemy, with tears flowing from her eyes. Thereupon the enemy army panicked. "Darkness fell, and the enemies slaughtered each other." In the 15th century, this miracle itself became a motif on icons as we can see in a 15th-century icon from Novgorod (p. 8).

Another miracle-working picture, the *Mother of God of Vladimir* (p. 10 right), warded off the Tartars several times when they laid siege to Moscow, while the *Mother of God of Smolensk*, together with the *Mother of God of Kazan* helped the Russians to victory over Napoleon's troops at the Battle of Borodino in 1812. Similar miracles were ascribed in Russia to various images of St Nicholas (p. 1), who was the most venerated of all the saints.

The theological importance of the icon

But how did it happen that the pictures of Christ, the Mother of God (Theotokos) and the saints played such a significant role in the Orthodox Church? For initially, Christians, like the adherents of the other two great monotheistic religions, Islam and Judaism, strictly rejected any pictorial representation of God. They accepted the Second Commandment, given by God to Moses on Mount Sinai: "Thou shalt not make unto thee any graven image, or any likeness of any thing that is in heaven above, or that is in the earth beneath, or that is in the water under the earth" (Exodus 20:4, Deuteronomy 5:8). The early Christians, surrounded by divine images of all kinds, needed neither a temple nor pictures in order to celebrate their divine service. But this attitude was not tolerated for long, and as the number of Christian believers increased, and their refusal to sacrifice to the gods and venerate the statue of the deified emperor with incense, as required of every citizen, was seen as an act of defiance towards the state, they were increasingly seen as a threat. Many Christians paid for their steadfastness in this matter with their lives.

From the beginning of the 3rd century, the strict ban on images was somewhat relaxed. Christians began to use symbols to decorate

city of Constantinople, named after him, on the Bosporus (today's Istanbul) 395 — Division of Roman Empire under Theodosius I
457 — Leo I becomes first Byzantine emperor to be crown by the Patriarch

2

**"Through thee we were rescued from perils,
through thee we found joy,
as a loving giver and glorious helper
we praise thee, who freest us from
errors and dangers,
thou mother of Christ our God …"**

From the Marian hymns of Theophanes Graptos, d. 845

objects: a dove, for example, or a fish, in Greek *ichthus*, whose letters were read as an acronym of *Iesus CHristos THeou Uios Soter* (Jesus Christ, Son of God, Saviour).

The Edict of Milan, issued in 313 by Emperors Constantine (*reg.* 306–337) and Licinius (*reg.* 308–324) following the end of the persecution of Christians which had taken place under Emperor Diocletian (reg. 284–305) proclaimed religious toleration and promoted conditions favourable for the development of a Christian art. Not only did the tradition that Constantine had defeated his rival Maxentius (*reg.* 306–312) at the Milvian Bridge near Rome under the sign of the Cross make Christianity "respectable", but debates such as those on the admissibility of images of Christ and the saints became a matter for the state. Evidently in the first Christian centuries there existed such pictures, or a desire for them, not only among the masses, but in the highest circles of the court. It is true that Bishop Eusebius of Caesarea (c. 263–339/40) decisively rejected the wish of Constantine's sister Constantia to possess a portrait of Christ. But the impetus had become unstoppable.

what is an icon?

But what is an icon, actually? Worldwide, celebrities from the worlds of sport and popular culture are described as such, and the word turns up everywhere in computer-speak. In this book, though, we are concerned with the sacred pictures of the Eastern Orthodox Church, where they play a central role and are venerated as part of the liturgy. All of these meanings go back to the Greek word *eikon* (εικων), which can be translated as image, depiction or likeness.

It was a long way from the strict rejection of icons and their veneration in the early days of the Christian era to the icon as the hallmark of Orthodox piety. Theologians reacted in different ways, both positive and disapproving, to the people's understandable desire, rooted in human nature, to possess pictures of people dear to them. The image issue was of altogether existential importance for Christian theology. As opponents of images could point to the Old Testament ban in the form of the Second Commandment, any acceptance of images had without fail to be theoretically well-founded. The basis was provided by the First Ecumenical Council, called by Constantine at Nicaea in 325. It stipulated that Christ was consubstantial with the Father, "true God of true God", but, through His

6th century — earliest still extant examples of painted icons
527–565 — Byzantine Empire achieves greatest extent under Emperor Justinian I

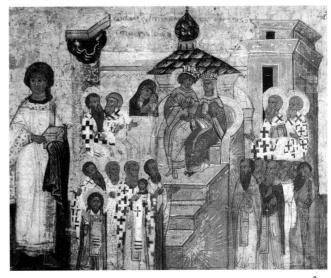

2. RUSSIA (NOVGOROD)

<u>The Miracle of the Mother of God of the Sign</u>
<u>(Battle between Novgorod and Suzdal)</u>
last quarter of 15th century, egg tempera on wood,
133 x 90 cm
Moscow, Tretyakov Gallery

3. RUSSIA (MOSCOW)

<u>The 7th Ecumenical Council, detail from:</u>
<u>The Saints and Feasts of the Church Calendar</u>
1st half of 16th century, egg tempera on wood,
157.9 x 90.5 cm
Recklinghausen, Ikonen-Museum

3

incarnation, also truly human. This meant that Christ, if He is recognized as consubstantial with the Father, was the image of God in human form, and that His human nature could thus be depicted in images. It was the incarnation of God in Christ that made possible God's pictorial depiction in the first place, and thus a rejection of images was, in this view, tantamount to a rejection of the Incarnation.

Those who venerated images countered the accusation of idolatry with the argument that it was not the physical matter of the image that was venerated, but the holy prototype, or, as the theologian Basil the Great put it: "The honour given the image passes to the prototype." The images of Christ and the saints may and should be venerated, with kisses, candles, incense, song etc., but they must not be worshipped, for worship is due to God alone.

тhe images not made by human hands

Alongside more and more theological arguments for images, their advocates also derived support from legends that, reporting the existence of original portraits of Christ and the Mother of God, thus

"proved" that images in themselves were good. According to one 6th-century legend, in order to heal him of a serious illness, Christ sent King Abgar V of Edessa a cloth on which was imprinted the image of His face. This cloth, known as the Mandylion, was miraculously rediscovered during the siege of Edessa by the Persians in 544 and, following the reconquest of the city by the Byzantines exactly 400 years later, taken to Constantinople. There, as a precious relic and imperial heirloom, it enjoyed the greatest veneration until it was stolen by the troops of the Fourth Crusade who sacked Constantinople in 1204. For Andreas of Crete (d. 740) and John of Damascus (d. 749), the Mandylion was proof of the legitimacy of icons and their veneration, and this argument played an important role in the disputes of the Iconoclastic Controversy. As a miraculously created image of Christ, "not made by human hand" *(acheiropoietos)*, showing His true appearance, it could be the model for all icons of Christ. Icons on which the Mandylion is depicted show the face of Christ without neck or shoulders against the background of a cloth, obligatory elements being the characteristic attributes of Christ's portrait – the crossed halo and the letters IC XC in the top corners (p. 24).

Other texts, dating from after the Iconoclastic Controversy, report that St Luke the Evangelist portrayed the Mother of God during

532 — start on construction of Hagia Sophia in Constantinople **540 — Byzantine general Belisarius conquers Ravenna**
611–619 — The Persians conquer almost all of Asia Minor and Egypt

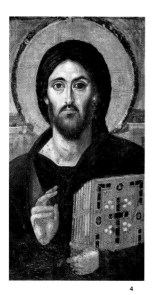
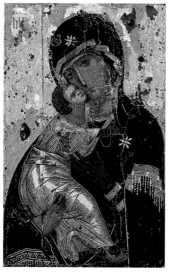

4 5

"Through the invisible, visible things become more profound for those who give themselves to contemplation."

Maximus Confessor, d. 622, Mystagogy, 2

her lifetime. From the 11th century, various specific Mother-of-God icons were then ascribed to Luke, such as the Hodegetria of Constantinople, the Mother of God of the Kykkos monastery in Cyprus, the Vladimirskaya and others.

The iconoclastic controversy and the "Triumph of orthodoxy"

It is hardly surprising that these legends made their appearance when they did, for during the conflicts in the 8th century with the Muslims, who were opposed to images, the number of Christians who rejected the veneration of images increased once more. The confrontations between the pro- and anti-icon parties culminated in the ban on the making and use of icons in churches by the Byzantine emperor Leo III in 726, and led to the Iconoclastic Controversy, which lasted for more than 100 years (726–843). Only during the period from 780 to 813 was this episode interrupted, the veneration of icons being reinstated by the Second Council of Nicaea in 787 and becoming finally established in 843. In this civil war, almost all existing icons, figural frescoes and miniature paintings were destroyed. Only where the writ

of the iconoclastic Byzantine emperors did not run were examples dating from the early period of icon-painting preserved, particular in St Catherine's monastery in Sinai (p. 10 left), and in Rome.

The victory of the supporters of icons, or iconodules, was celebrated as the "Triumph of Orthodoxy". The anniversary, commemorated on the first Sunday in Lent, was depicted on a number of icons, the one in the British Museum in London being the oldest still extant (p. 15). Probably painted in Constantinople in the 14th century, it reflects the procession of icons which took place at the time through the streets of the Byzantine capital, beginning at the church of Our Lady of Blachernes, culminating in a service at Hagia Sophia, and ending at the imperial palace. The icon shows, top left, Empress Theodora, who in 843 was regent for her under-age son Michael III. To the right, next to the Mother-of-God icon, Patriarch Methodios can be seen in episcopal garments. In the bottom row, a number of famous iconodule martyrs are depicted, holding in their hands two icons of Christ Emmanuel. A further, larger icon can be seen top centre. It stands on a plinth, which is covered with a red cloth and held by two men with tall hats and difficult-to-interpret wings. It is the famous icon of the Mother of God Hodegetria, which legend has it was painted by St Luke the Evangelist and had become the heirloom of the Byzantine capital.

622 — Mohammed leaves Mecca for Medina on 15 July; start of Islamic calendar

638 — Caliph Omar conquers Jerusalem

4. BYZANTIUM

<u>Christ Pantocrator</u>
1st half of 6th century, encaustic on wood,
84 x 45.5 cm
Sinai, St Catharine's monastery

5. BYZANTIUM

<u>Mother of God of Vladimir (detail)</u>
c. 1131 with later additions, egg tempera on wood,
78 x 55 cm
Moscow, Tretyakov Gallery

6. ANTINOPOLIS (EGYPT)

<u>Portrait of a Young Man (mummy portrait)</u>
c. 120–130 CE, Encaustic on wood with gold leaf,
41 x 20.2 cm
Berlin, Staatliche Museen zu Berlin – Ägyptisches
Museum und Papyrussammlung

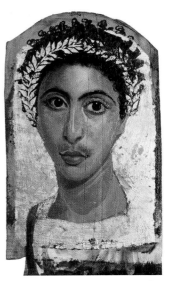

6

The imagery of icons

The view of the role of the icon as the vicarious presence of the depicted saints, and the necessity that the imagery of icons be understood everywhere and by all believers, was not without consequences for the form and content of the artistic depiction. The likeness between image and prototype as demanded by the Church meant that icon-painters were not allowed to paint the sacred persons and biblical scenes freely according to their imaginations, but had to keep to traditional archetypes. These were handed down through drawings and what were known as "painters' manuals". As sources since the 15th century show, Cretan icon-painters used drawings passed down from generation to generation. An extensive sketchbook dating from the 15th century, recently published, kept in the Iveron monastery on Mount Athos, which like some Russian "podlinniki" (for example the so-called Stroganov manual, which dates from shortly before 1606) reproduces the drawings of individual saints and scenes. By contrast, the famous *Mount Athos painters' book*, or *Hermeneia*, by Dionysios of Fourna, which dates from the period between 1730 and 1734, contains exclusively descriptive instructions on technology and iconography.

The icon does not show a detail of the earthly world, but points to a supernatural and eternal reality. For this reason, the painters had to avoid anything that could evoke the impression of spatiality, plasticity or a particular time. In place of perspective space, we mostly find on icons an immaterial golden or monochrome background, which emphasizes the two-dimensionality of the scene depicted. Central perspective, usual since the Renaissance, is as a rule replaced by "reverse perspective", where the vanishing point lies in front of the picture and within the beholder who receives the message of the picture.

Landscapes and architecture give only symbolic clues to the place of the action, and do not depict some illusionist stage. The sacred figures are depicted in representative attitudes, most often in frontal or axial view, in order to create the direct relationship between picture and beholder. Understandably, emotions such as laughter or tears are absent from such timeless, representative "portraits". If an icon contains a number of figures of different size, this does not mean that the smaller person is further away from the beholder, but that he or she is of lesser importance or lower rank. Important figures or pictorial details must not be covered or overlapped by less important ones.

Unlike Western paintings since the Renaissance, the scenes or figures on icons are not illuminated by a source of light from the side

680 — Bulgars enter territory south of the Lower Danube after defeating Byzantine forces
726–843 — Iconoclastic Controversy rages in Byzantium, with an interruption from **780 to 813**

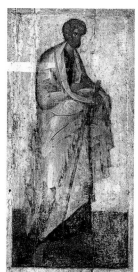
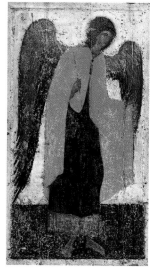
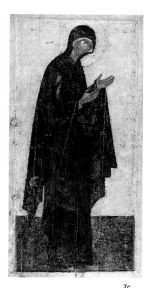

7. THEOPHANES THE GREEK (?)

<u>Icons from the Deësis Tier</u>
St Peter, Archangel Michael, Mother of God,
Christ, John the Baptist, Archangel Gabriel,
St John Chrysostom
c. 1399, egg tempera on wood,
height: 210 cm
Moscow, Cathedral of the Annunciation in
the Kremlin

7a 7b 7c

outside the picture; rather, all colour and all light emanates exclusively from the objects in the picture themselves. In Western painting, the light *shows* what is depicted, the objects and persons have illuminated and shaded sides, they cast shadows and thus become corporeal and spatial. By contrast, on an icon, the image and the source of light are identical. This "radiance" makes visible the transcendental, the divine in the picture, and illuminates the beholder. Just as there are no shadows in icon-painting, there is no atmospheric depiction to blur distant objects.

In order to guarantee the identity of image and prototype, in other words in order to guarantee the unambiguous identification of the depicted person or of the depicted scene, the icon must include, without fail, an inscription. For according to John of Damascus, "Divine mercy is bestowed on the material through the naming of what is depicted in the picture." (*De imaginibus,* oratio I, 36)

The restrictive effect of these prescriptions on artistic freedom has often led to icons being disparaged as stereotyped and conventional in Western eyes, which saw as naturalistic a depiction as possible as the *non plus ultra* of the development of art. But hardly any icon is the same as any other. If one looks, one will see that there are not only greater or lesser differences between icons of different periods,

but also between Russian, Greek, Serbian, Bulgarian, Romanian, Georgian and oriental icons, and within these countries also between the individual regions, workshops and painters.

icon themes

The themes of icons also encompass a much broader range than is generally believed. Even the individual portraits of Christ and the Mother of God can be found in countless variations. Christ is mostly represented as the Pantocrator, the Ruler of All, on the model of the Byzantine emperors: enthroned, standing or half-figure, with a closed or open book of gospels in His left hand, while His right hand is raised in a gesture of blessing or communication. But in addition we find His portrait against the background of a cloth (the Mandylion mentioned above), as the dead Christ in the grave, and many other depictions. Particularly varied are the representations of the Mother of God, mostly with her divine child, rarely alone: standing, majestic, in half or full figure, or simply restricted to her head; her arms raised in prayer, holding her child on one or other arm, nursing Him, kissing Him or presenting Him to the faithful. Another popular motif is angels, above all the

787 — Seventh Council of Nicaea temporarily sanctions veneration of images once more 800 — Charlemagne crowned
Emperor of the Romans by Pope Leo III in Rome; Frankish empire in West forms a counterbalance to Byzantine Empire in East

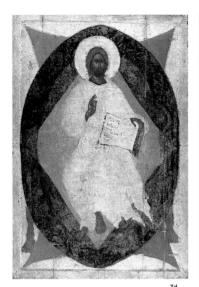
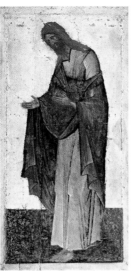
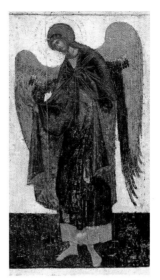
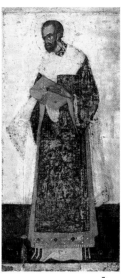

| 7d | 7e | 7f | 7g |

Archangels Michael and Gabriel; on later Russian icons, the guardian angel also becomes very popular. In addition, icons depict the saints venerated in the Orthodox Church and scenes from their lives, as well as events from the Old and New Testaments. Here, the feast-day icons play a central role, with the most important events of the life of Christ and the Mother of God. Icons also illustrate the texts of hymns and prayers, depicting abstract theological concepts such as the Holy Trinity and the Deësis (supplication; pp. 12–13).

тhe placing of icons in churches

From the outset, icons were painted in various sizes and shapes. Smaller, portable icons were suited to private devotions. The usual Russian domestic icon measures approximately 31 x 26 cm, but particularly in the 19th century very small icons were sold as pilgrimage souvenirs in monasteries and other destinations. Large, and sometimes truly monumental icons served to decorate churches and monasteries, where they were mostly placed on a screen known as an iconostasis or templon, which divided the nave, where the congregation assembled, from the sanctuary. The iconostasis developed from the early-Christian choir-screen, a low marble balustrade with an entrance in the middle. In the 5th century this was heightened by means of small columns carrying an architrave. The spaces between the columns were closed off by curtains during particular phases of the liturgy. While before the Iconoclastic Controversy at most the architrave was decorated by depictions of saints, later large icons were placed between the columns, and the architrave was painted with depictions of the Deësis or with the cycle of feast-days (pp. 16–17). The entrance was closed off by a double door, which as a rule was painted with the motif of the Annunciation.

Thus there arose a fixed icon screen, which concealed the altar and the sacred acts from the view of the faithful. Only at particular moments of the liturgy were the doors opened to give a view of the altar. The iconostasis witnessed the culmination of its development in Russia, where from the 15th century it was as high and broad as the sanctuary itself (p. 14 left). The mostly wooden frame accommodated three rows or tiers of icons at first, but this number later grew to five or six, the programme, structured both horizontally and vertically, being strictly laid down. At floor level, three entrances provided access to the sanctuary. The central one, known as the Royal or Tsars' Door (p. 14 right), led to the altar and could only be used by the celebrant. The

860–1240 — Period of Kievan Rus'
863 — The "apostles to the Slavs" Cyril and Methodius are commissioned
by Emperor Michael III to Christianize Great Moravia, and later Pannonia and Bulgaria

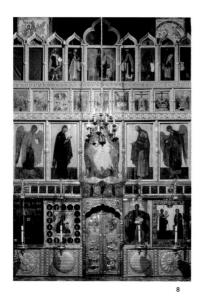
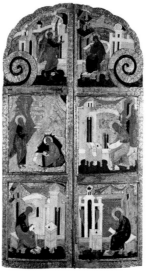

8 9

"The world is a cosmic temple whose priest is man."

Maximus Confessor, d. 622

model for most Russian Royal Doors was the central door of the iconostasis of the Holy Trinity cathedral at the Trinity-Sergei monastery near Moscow: it was painted by masters from the circle of Andrei Rublev in 1425–1427.

To the right of the Royal Door is the icon of Christ, to the left that of the Mother of God. Next to the Christ icon is the icon of the patron saint, or the event to which the church is dedicated, and next to the Mother of God icon is the icon of a saint particularly venerated locally, as a rule with scenes from his life in the marginal fields. Above this "Local Tier" – or in some cases since the mid 17th century below it – is the Deësis Tier centring on Christ Pantocrator, to whom on either side saints and archangels bow in intercession, begging forgiveness for the sins of mankind. They are led by the Virgin and John the Baptist. The next tier depicts the major feasts of the Church, depictions from the life of Christ and the Mother of God.

Towards the end of the 15th century the iconostasis was enlarged by the addition of a Prophets' Tier, and in the 16th by the Patriarchs' Tier. While the scenes on the Feast-day Tier are taken from the New Testament, the two upper tiers symbolically embody the Old Testament: prophets with scrolls in their hands, the texts pointing to the coming of Christ, turn towards an icon depicting David, Daniel and So-

lomon, later with the Mother of God in the middle. Above them the Patriarchs are grouped around the central icon of the Trinity. The iconostasis is crowned by a painted wooden cross.

Thus the iconostasis visualizes for the whole congregation the liturgy whose climaxes, conversely, it conceals. The heavenly hierarchy assembled on the icon screen conveys to the faithful the mystery of salvation not only during the services, but also during silent prayer.

The history of icon-painting

It is barely possible to give an outline history of icon-painting in just a few pages, bearing in mind that, for one thing, we are talking about the development of an art which made use of a whole variety of techniques. Each of these, whether icons painted on wood, metal icons, ivories, enamels etc., would need a treatise of its own. Secondly, icons were produced in, and distributed across, a vast geographical area, from the Byzantine heartland in Asia Minor and the Near East via the Aegean and the Balkans to Italy, and from Egypt and Ethiopia via the Carpathians to Russia and the Caucasus. In each of these territories, in each region, the different historical and economic configura-

988 — Christianization of the Kievan Rus' and Eastern Orthodox churches

1054 — Start of Great Schism between Roman Catholic
1077 — Seljuks take Jerusalem

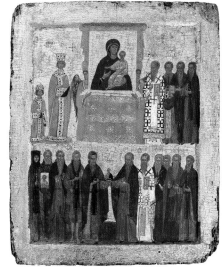

10

tions, the respective artistic influences and religious currents gave rise to individualities of style and motifs in religious art. And thirdly, these were in turn subject to many changes over the centuries. For we are looking back on one-and-a-half millennia of icon-painting.

The first reports of the existence of pictures of saints are known to us from the writings of the "father of Christian history" Bishop Eusebius of Caesarea (c. 263–339/340), although the earliest examples still extant date only from the 6th century. As all icons, figural frescoes and other depictions were destroyed by the Iconoclasts, only those examples have been preserved which during the Iconoclastic period were beyond the reach of the iconoclastic Byzantine emperors, namely in St Catherine's monastery in Sinai, which had already been conquered by the Arabs, or else in Rome. From here icons have been handed down which are among the most beautiful ever made. Some still belong to the artistic tradition of Antiquity, familiar to us from the mummy portraits discovered in Fayum oasis in upper Egypt (p. 11). Like these, they are painted either in egg tempera or encaustic on wood. The latter technique, no longer used in the post-Iconoclastic period, involves mixing hot wax with pigment and applying it with a spatula. Works painted in encaustic are works of art of the highest order, exhibiting naturalness, chiaroscuro illusionism and an almost im-

pressionist style (p. 10 left). Contemporary with this style was another, "monastic" style, which rejected this illusionism and employed an austere linear technique.

Following the division of the Roman Empire into Western and Eastern halves in 395, the city of Constantinople, founded by Emperor Constantine on the Bosporus in 330, became the capital of the Eastern, or Byzantine, Empire, which attained its maximum extent under Emperor Justinian I (*reg.* 527–565). Art too witnessed a culmination in this period, but the Iconoclastic Period left few works of art intact in Constantinople itself. All the more impressively, then, do the mosaics in Ravenna bear witness to its quality and splendour. Following the Iconoclastic disturbances, which verged on civil war, the Byzantine Empire recovered under the emperors of the Macedonian dynasty, which also gave its name to a contemporary artistic renaissance (867–1025), in which classical models played an important role. Thanks to the economic prosperity of the empire, icons were produced in the most precious of materials and techniques: cloisonné enamel (p. 18 left), gold, silver and ivory, such as those of the famous Romanos group. In addition, it was not just the walls and ceilings of churches that were decorated with mosaics, but icons too – the stones being sometimes no larger than a pin-head. The Macedonian emperors were followed in the

1096–1109 — First Crusade **1147–1149 — Second Crusade**

1186 — Bulgaria secedes from Byzantium, Byzantine control of Balkans finally disintegrates

"ın the holy pictures we see as it were a reflection of the heavenly tents and cheer in holy joy."

Byzantine calendar, vespers for the first Sunday in Lent

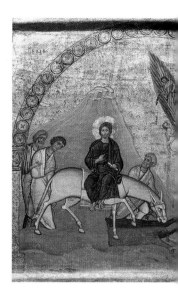

11. BYZANTIUM

<u>Panel with three Feast-day scenes (Entry into</u>
<u>Jerusalem, Crucifixion, Harrowing of Hell)</u>
12th century, egg tempera on wood, 44 x 118 cm
Sinai, St Catharine's monastery

second half of the 12th century by the era named after the Comnenian dynasty, which was characterized by an expressive, dynamic style with flowing garments, strong colour-contrasts and abrupt movements (p. 18 right).

The incredible splendour of the Byzantine capital naturally attracted enemies. On 13 April 1204, soldiers of the Fourth Crusade, led by the Venetian Doge Enrico Dandolo, occupied not the Holy Land but the Christian city of Constantinople, pillaging all the churches, palaces and monasteries. Almost all the riches and works of art that were not destroyed landed in the West, where even today numerous Byzantine works are preserved in monastic treasuries like that of San Marco in Venice. Although Constantinople was reconquered from the Latins by Michael Palaiologos in 1261, the Byzantine Empire never regained its former political and economic importance, and its territory gradually shrank to just a few regions around the capital. But art and science flourished as never before, so that we can once again speak of a "renaissance", the Palaiologan. The art is distinguished by the emotionality and dynamism of the figures, and the striving for plasticity (p. 19).

This artistic heyday came to an abrupt end with the occupation of Constantinople under Sultan Mehmet II on 29 May 1453. Although the Orthodox patriarchate is based in Istanbul to this day, the Christian

upper echelons (emperor and nobility) disappeared as patrons for artistically high-quality icons, as the ruling class was now Islamic. This was true more or less of all the countries conquered by the Turks in the 14th and 15th centuries, where icons continued to be painted for the Christian population, but in what was if anything a folksy style. Things looked different, however, on those Aegean and Ionian islands which had been brought under the control of western rulers during the Fourth Crusade in 1204 or even earlier. Also in this category was Cyprus, which was conquered by the Crusaders in 1191 and developed an autonomous style of icon-painting, naturally not without Western influences.

ıcon-painting on crete

The most important centre of post-Byzantine art was the island of Crete, which was ruled by Venice from 1210 until its final conquest by the Ottomans in 1669, when its capital Candia, today's Herakleion, fell. Relations between the Catholic Venetians and the Orthodox Cretans were tense, sometimes seriously so. But the island's economy and art flourished, and in the 15th century numerous artists and intel-

1204 — Fourth Crusade, Christian crusaders take Constantinople, foundation of Latin Empire

1210 — Crete falls to Venice **1240 — Mongol invasion of Russia, Mongol (Tartar) rule in Russia lasts until 1480**

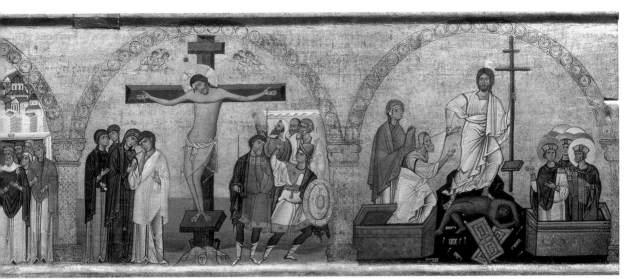

lectuals arrived from threatened Byzantine provinces and above all from the capital Constantinople. The creative combination of Byzantine traditions and Western influences is characteristic of the working practices of Cretan painters. In their workshops they used drawings based on old icons, which they sometimes followed faithfully, but they also employed engravings and reproductions of Italian and Netherlandish paintings. A large number of painters are known to us by name, as they often signed their icons. Some of them painted either *alla latina* or *alla greca*, depending on the wishes of the Venetian or Cretan client. New icon types dating from the second half of the 15th century, such as the "Mother of God of the Passion" or the "Madre della Consolazione" were produced and exported by the hundred. Among the most famous painters of the 15th century were Angelos Akótantos (active c. 1430–1450), Andreas Ritzos (c. 1421–1492) and his son Nikolaos (c. 1460–1503), Nikolaos Tzafoures (mentioned 1487–1500) and Andreas Pavias (1470–before 1512). In the 16th century Michael Damaskinos (1530/35–1592/93), Theophanes Strelitzas Bathas (alias Theophanes the Cretan, c. 1500–1559), and Domenikos Theotokopoulos (better known as "El Greco", 1541–1614), who started out as an icon-painter before becoming internationally famous in Toledo, are worthy of mention. Some of these artists

worked for a while in Venice, such as Michael Damaskinos, who between 1574 and 1584 created numerous icons for the iconostasis of the church of San Giorgio dei Greci, home to the local Greek congregation. Likewise in the second half of the 16th century we find Georgios Klontzas (c. 1530–1608), who is especially famous for his triptychs and his brilliantly coloured dynamic compositions with their multitudes of tiny figures. The 17th century also had painters working in a more traditional idiom, such as Viktor (mentioned 1660–1697) and Emmanuel Lampardos (1587–1631). The tradition of Klontzas, by contrast, was continued by painters such as Neilos, a monk, and, right into the 18th century, by Ioannes Kornaros (1745–1821).

The struggle for Crete in the years between 1645 and 1669, and the final defeat of Candia by the Turks, caused many important painters, for example Elias Moskos (d. 1687), to emigrate to the Ionian islands of Zakynthos, Corfu or Kefalonia. In the same period, some of the most important painters, such as Emmanuel Tzanes (d. 1690) and Theodoros Poulakes (1622–1692), were invited to Venice. Emmanuel Tzanes was, from 1665 until his death in 1690, a priest at the Greek church of San Giorgio dei Greci in Venice, where he created numerous icons, using as his models both 15th-century icons and works of the early and late Renaissance. Theodoros Poulakes spent

1241 — a German-Polish army is defeated by Mongols at Legnica
1261 — Michael Palaiologos reconquers Byzantine Empire from Latins

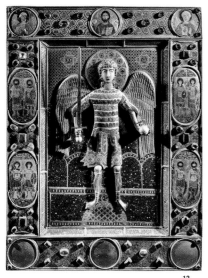

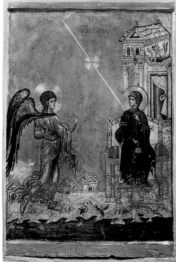

12 13

12. CONSTANTINOPLE

Archangel Michael
late 11th/early 12th century, silver gilt, cloisonné
enamel and precious stones, 46 x 35 cm
Venice, treasury of San Marco

13. BYZANTIUM

The Annunciation
late 12th century, egg tempera on wood,
63.1 x 42.2 cm
Sinai, St Catherine's monastery

14. BYZANTIUM

The Twelve Apostles
early 14th century, egg tempera on wood,
38 x 34 cm
Moscow, Puskin-Museum

some of the time from 1645 in Venice, but settled in Corfu from 1657/58 to 1670. He knew the work of Netherlandish artists, and often used engravings by Johann Sadeler the Elder (1550–1600) as the models for his own colourful and lively compositions (pp. 20 and 21).

The Balkans

It is particularly hard to summarize the history of icon-painting in the Balkans in a few lines. The borders between Bulgaria, today's republic of Macedonia, Serbia, Romania, Greece and Albania were shifting all the time, with the result that such different works were produced as the icons in the Marco monastery near Skopje (revealed only a few years ago), which are among the best documents of Palaiologian art, and the folksy reverse-glass icons from Transylvania, painted during the period of Habsburg dominance in the 18th and 19th centuries. In the 1980s, a number of 6th-century clay icons were discovered near the village of Vinica in what is now the Republic of Macedonia; they were probably used to decorate church walls, and are among the earliest documents of icon art we have. Ohrid, like Thessaloniki in

northern Greece, the second city of the Empire, became a centre of icon-painting, strongly influenced by the Palaiologan art of the capital (p. 22 left). The period of Turkish rule witnessed the growth in importance of village painting schools, such as Trjavna in Bulgaria, as well as workshops led by well-known painters in the towns. In Serbia, the artistically outstanding and well-preserved frescoes in the monastic churches, painted above all under the Nemanyid dynasty in the 13th and 14th centuries, suggest that there were icons of similar quality, few of which however have survived.

Byzantines, Serbs, Bulgars, Georgians and Russians all founded monasteries in the monastic republic on the Athos peninsula. However Athos never developed a style of its own, as the icon-painters in the monasteries painted in the style of their countries of origin or else accepted icons as gifts from pilgrims, who would have brought them from their home countries.

Russia

It was in Russia, following the Christianization of the Kievan Rus' in 988, that icon-painting witnessed its most varied and lasting devel-

1330 — Start of Serbian dominance in Balkans

1365 — Adrianopolis (today's Edirne) becomes Ottoman capital

1387 — Ottomans take Thessaloniki

"when I first saw a picture by cimabue, who is more Byzantine than other Renaissance painters, I preferred it at once to all the pictures I had seen before and which had been painted since."

Alberto Giacometti in an interview in 1964

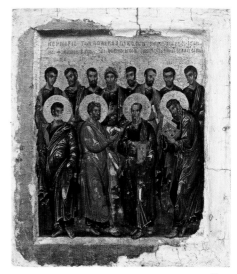

14

opment. The first icons were imports from Byzantium, such as the famous *Mother of God of Vladimir*, dating from the first half of the 12th century (p. 10 right). Byzantine icon-painters came to the Rus' to decorate the newly built churches, and taught their art to local painters. Few icons have survived from before the time of the Mongol invasion in 1240.

New centres arose, including the cities of Vladimir and Novgorod. Novgorod had developed since the 11th century into an important trading centre. Thanks to its location in the middle of inaccessible marshes, it was the only Russian city to be spared the Tartar invasion, which among other things sealed Vladimir-Suzdal's fate in 1237. In Novgorod, where the citizenry enjoyed great political influence in the city council, there developed a highly individual painting style, in which particularly popular figures such as St George (p. 22 right), along with some otherwise unknown historical motifs such as the *Battle between Novgorod and Suzdal* (p. 8), were painted. Characteristic of these icons are their almost laconic, minimalist composition, and their coloration, in which red, green, ochre and white dominate. In 1378 one of the greatest Byzantine artists of the age came to Novgorod: Theophanes the Greek, or Feofan Grek, to give him his Russian name (c. 1330/40–1410). He aroused great admiration in his contemporaries, as he painted expressive and dynamic frescoes and icons with great speed without the help of drawings (pp. 12–13).

Russian icons are frequently classified by "school", the word being used in the sense of "style" (of a city or region), and not in that of "teaching institution". But apart from a few "typical" examples, the attribution of icons to schools is very often problematic. One reason is that icons are portable and the place where one is found may well not be where it was produced. Another is that in recent decades, the discovery of more and more new icons, and the exposure of hundreds of overpainted ones, has made it clear that the stylistic differences between the various schools are much less clear than previously assumed. Technical investigations have shown that often enough, one and the same artist manifested the stylistic features of a number of painting schools. If a monastery had its own workshop, which was not always the case, the in-house painters would limit themselves to the "renovation" of damaged icons or the mass-production of icons of the founder or of the feast of its patron, which were handed out to pilgrims in thanks for donations. No monastery, however, could permanently employ the real artists among the icon-painters. If icons were to be painted for the iconostasis of a church, a small team of famous masters was often specially invited from a considerable distance.

1389 — Battle of Kosovo Polje: Serbs succumb to Ottoman Turks

1396 — Ottomans annihilate a Christian army at Nikopolis

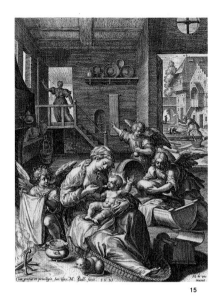

15

"kiev was to become a city 'which was illuminated by the light of holy icons, was filled by the scent of incense, was full of praise and resounded to holy heavenly chanting'."

Ilarion, the first Metropolitan of Kiev, end of the 10th century

The Grand Duchy of Moscow grew stronger in the 14th and 15th centuries; the transfer of the seat of the metropolitans to Moscow from Vladimir in 1326, and the defeats of the Mongols in 1380 and 1480, gradually helped it to religious, political and cultural pre-eminence. After the Fall of Constantinople, the city even claimed for itself the status of the "Third Rome". The Kremlin was enlarged and ornamented with stone churches, which in turn were decorated with tall iconostases, for which the greatest artists of the age were brought in. In 1395, Feofan Grek came from Novgorod to Moscow, where he oversaw the decoration of the Church of the Nativity of the Virgin in the Kremlin, and in 1405, together with Andrei Rublev (c. 1360–1430), he painted the Cathedral of the Annunciation, also in the Kremlin. The latter is regarded as the greatest Russian icon-painter of all, and his icon of the Holy Trinity, painted for the Sergei-Trinity monastery, is the most famous of all Russian icons (p. 2). The mid 15th century saw the birth of Dionisii (d. 1508), who executed the frescoes in the church of the Nativity of the Virgin in the Feropontov monastery. Few icons by him are still extant; they are distinguished by slim, elegantly moving figures, and delicate colours (p. 23).

By the 16th century, Moscow had brought the other centres under its rule, which in icon-painting led to a new style, which fused together all the local influences. After the devastating Fire of Moscow in 1547, the Tsar had artists come from all the provinces of the Empire to rebuild the city.

Towards the end of the 16th century, a trend appeared in icon-painting which was to exert a great influence until well into the 19th. Icons of this kind were often linked to the Stroganovs, a rich merchant family based in Solvychegodsk, who lived mainly from trading in salt and furs. The icons are distinguished by delicate miniature painting, intimate formats and costly decoration.

In 1653, during the rule of the Romanov dynasty, a schism opened up in the Russian Church when Patriarch Nikon sought to return liturgical texts and ecclesiastical customs to original Greek models. The so-called Old Believers remained true to both the motifs and the style of the old traditions of icon-painting, and also gathered up in great numbers the old icons that the churches and monasteries had systematically replaced by more modern ones, and so built up substantial collections in the process.

Simon Usakov (1626–1686) and his pupils, by contrast, who worked in the workshops of the Kremlin armoury, adopted a new, Western-influenced style, which had been brought to Moscow by foreign artists (p. 24). Familiar with central perspective, anatomy and chiaro-

1453 — fall of Byzantine Empire; on 29 May Sultan Mehmet II takes Constantinople, the Christian city on Bosporus becomes capital of Ottoman Empire

1480–1612 — Grand Principality of Moscow: Ivan III

15. JOHANN SADELER THE ELDER

<u>The Holy Family in Egypt</u>
1581, copperplate engraving, 19 x 13 cm
Berlin, Staatliche Museen zu Berlin – Kupferstich-kabinett

16. THEODOROS POULAKES

<u>The Nativity of Christ</u>
1675, egg tempera on wood, 47 x 65 cm
Venice, Museo Civico Correr

16

scuro painting, they used this knowledge in their icons, which they also often signed in the Western manner.

Under Peter the Great the capital of the Russian Empire was transferred to St Petersburg, a city only founded in 1703, where the tsar founded an academy of art on the Western model. While the artists busied themselves with portraits and landscapes, icon-painting took a back seat. The enormous demand for icons in the tsar's huge empire, meanwhile, was met by commercial artists working in the artists' villages of central Russia. They produced icons both in the old style and in accordance with modern trends, sometimes on a scale verging closely on the industrial. But alongside the mass-production of goods for the masses, they also produced masterpieces in the tradition of the Stroganov icons.

In the early 20th century, avant-garde Russian artists, in particular Wassily Kandinsky (1866–1944), Kasimir Malevich (1878–1935) and Alexei von Jawlensky (1864–1941) "discovered" the icon, which, in its luminous coloration, its two-dimensionality and its concentration on the supra-personal, corresponded in many ways to their own ideas (p. 25). The German Expressionist painter Karl Schmidt-Rottluff (1884–1976), writing to Jawlensky in 1934, expressed himself in this spirit when he spoke of the "silent, spiritualized pictures, which I would

describe as truly modern saints' pictures. It seems to me that in these, an old icon-painter of your people has come back to life once more, so genuine and devout and lost in his work, the like of which we see nowhere today."

The technique of icon-painting

The term "icon" was never tied to a particular technique or particular materials. Already in the proceedings of the Seventh Ecumenical Council, held at Nicaea in 787, which was of central importance for the veneration of images, we read: "We therefore ordain with all care and circumspection that the venerable and sacred images which have been made in the same way as the venerable and life-giving cross with paints or mosaics or of some other worthy material in a fitting manner, are to be set up and honoured in God's holy temples." By "other worthy material" people understood, among others, ivory, gold, silver and baser metals, textiles, and marble.

From late-Byzantine times onwards, one technique had achieved a particularly broad distribution in icon art, namely painting in tempera, in which the binding medium was an emulsion of egg-yolk in

detaches his empire from Khanate of the Golden Horde and turns the Kremlin in Moscow into a fortress
1529 — Turks besiege Vienna for first time **1547 — Fire of Moscow**

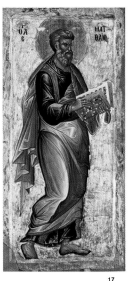

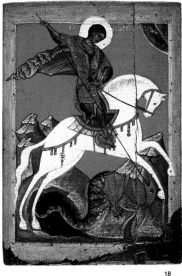

17 18

17. OHRID

St Matthew the Evangelist
c. 1295, egg tempera on wood, 105 x 56.5 cm
Ohrid, St Kliment Icon Gallery

18. NOVGOROD

St George and the Dragon
2nd half of 15th century, egg tempera on wood,
58.8 x 42 cm
St Petersburg, State Russian Museum

19. DIONISII

Crucifixion
from the Feast-day Tier of the Pavel Obnorski
monastery
1500, egg tempera on wood, 85 x 52 cm
Moscow, Tretyakov Gallery

water. It is one of history's oldest painting techniques; it had already been used in Antiquity (e.g. for a large number of Egyptian mummy-portraits) and been described by Pliny the Elder (23–79 CE) in Book 35 of his *Naturalis historia*. Every icon in this medium is built up of four layers: first the picture-support, in other words the wood panel; then the ground (in Russian: *levkas*), prepared from powdered chalk or alabaster bound with animal glue; thirdly the actual paint-layer, consisting of pigments bound with egg-yolk, and finally a protective layer of vegetable oils or varnish.

The picture-support for portable icons, from the earliest days until the present, has been almost exclusively well-seasoned wood. The picture was painted on the side facing the heart of the trunk, which, in the course of time, tends to bulge outwards. The verticals in the picture, which is in portrait format, must run parallel with the grain of the wood. For smaller icons, one board is usually enough, while for larger sizes, several boards are joined together (usually) by means of horizontal bars on the reverse. These bars would, for preference, be made of harder wood, and served also to prevent warping. The side to be painted would be slightly hollowed, using a plane, and this shallow hollow would be reserved for the main motif. The raised border around the hollow would often be painted with the figures of saints or expla-

natory texts. Later, icons were often painted on flat boards without the hollow, or else canvases or thin panels were used.

In order to protect the paint layer from cracking or flaking when, as was almost inevitable, the board warped, a cloth was sometimes stuck on to the latter before the ground was applied. This was the next step. The ground consisted of powdered chalk or alabaster mixed with water-soluble fish-glue and applied in a number of layers until the desired thickness of 3 to 5 mm was achieved. Then the surface was smoothed with a knife, a bristle brush or the hand, and polished with scouring-rush or pumice. The ground had to be white, homogeneous, absolutely smooth, and firm, so that it provided maximum luminosity for the paint-layer and did not absorb the binding medium of the paint. This technique remained unchanged for centuries.

The icon-painter would then make an underdrawing on the smooth, white ground before starting the painting. Particularly when the gilding of haloes or background was planned, he would score the lines with a stylus, as they would otherwise have been covered by the gold leaf. For the highlighting of particular areas, above all backgrounds and haloes, both gold and silver leaf, more rarely copper or tin, were used. 19th and 20th-century icons were often covered with tin, which was then painted yellow to look like gold. Folds in garments, the

1613–1917 — Romanov dynasty rules in Moscow 1669 — Crete conquered by Turks
1683 — Turkish siege of Vienna broken by forces under King John Sobieski of Poland

22

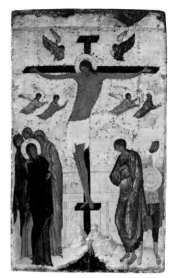

19

" … l'hypnose de вyzance" was the description given by аndré маlraux in the 20th century to the same sublime simplicity of icon painting, always confined to the essential, the same expression in the wide-open eyes of the saints.

rays of the mandorla, angels' wings, hair, thrones and benches were often decorated with fine gold-leaf lines. This technique, known as *assist* or *chrysography*, was performed only after the paint-layer was finished and dry.

The paints consisted of a precipitation of very finely ground pigments in the binding medium. The icon-painters made do with relatively few pigments, which were often difficult to manufacture. Rarely did the old Russian artists use pure colours; more often they mixed them in order to create as many shades as possible.

The essence of egg tempera is the overlayering of semi-transparent coats. The applications followed a fixed sequence. The painter began by painting in the areas enclosed by the drawn contours with a single colour. In this way, he provided the basis for the colour composition before setting to work on the details. First, all the outlines were applied in a darker colour with a fine brush. The lighter shades in the garments were achieved by applying successively lighter layers of paint. By adding more and more white, smaller highlights were attained on the underlying surface; shadows were achieved correspondingly, using darker, translucent paints. After completing the highlights of the garments and architectural and landscape motifs, the painter would proceed to the flesh tones, in other words the uncovered por-

tions of the body, such as the face, hands and feet. These areas were prepared with an underpainting in one or other shade of brown. Details were achieved by applying ochres, white and other colours on top of the brown.

In order to protect the painting and the ground from the effects of humidity, the final stage was to cover the icon with a layer of oils. This protective layer also bound the paint-layers firmly to each other and to the ground, besides intensifying the luminosity of the colours.

The value of the sacred images was often further increased by providing them with a decorative metal frame known as an *oklád* or *ríza*. Until the 19th century, these would be of precious metals, mostly silver, which was sometimes gilded or decorated with enamel or niello. While in the early days these metal settings were used primarily for especially venerated icons, demand for magnificent-looking specimens increased sharply in the 19th century. But as they also had to be affordable for the many poor, this led to a far-reaching mechanization of the production of icon settings, and the substitution of the once normal precious metal by copper or brass. The last third of the 19th century ushered in the era of mass-produced icons, in which − in contrast to earlier practice − only the faces and hands were painted, the rest being covered by a perforated *ríza*.

1699 — Treaty of Karlowitz ends Austro-Ottoman War; Austria retains Hungary, Transylvania, Bosnia and Croatia
1703 — foundation of St Petersburg

20

"Every artists works within a tradition. I was born a Russian. My Russian soul was always close to old Russian art, the Russian icons, Byzantine art, the mosaics of Ravenna, Venice, Rome and Romanesque art. All these arts always brought my soul into a holy vibration, as I felt a profound spiritual language in them. This art was my tradition."

Alexei von Jawlensky, 1939

Icon treasures in the major collections

Icons share the fate that has befallen so much sacred art in East and West: often enough, they, and in particular the most beautiful among them, have left the churches and changed from being cult objects to objets d'art. From Munich to New York, from London to Paris, the number of touring exhibitions is constantly increasing. Museums and galleries think themselves lucky to be able to present the beauty of these "sacred images" in their rooms.

The most important collections of icons are, naturally enough, to be found in their countries of origin, namely in Russia (e.g. the Tretyakov Gallery and Rublev Museum in Moscow, the State Russian Museum and the Hermitage in St Petersburg), in Greece, in St Catherine's monastery in Sinai, in the Ukraine, Serbia, the Republic of Macedonia and in Bulgaria, as well as countries with Orthodox minorities such as Poland and Slovakia.

Most of the Western collections offer a selection that was compiled, if anything, at random, whether through donations or chance purchases of private collections. They are mostly housed in subsidiary departments of the major museums (e.g. the Louvre in Paris, the British Museum in London, the national galleries in Oslo and Stockholm, the Ny Carlsberg Glyptotek in Copenhagen and the Musée d'art et d'histoire in Geneva, to name but the most important). Much the same is true of Italy, for example the Galleria Nazionale in Ravenna, the Uffizi in Florence and the Pinacoteca Vaticana in Rome. However there are two Italian museums devoted exclusively to icons: the Intesa Sanpaolo collection established in the mid-1990s at the Palazzo Leoni Montanari in Vicenza, which has only Russian examples, and the icon museum attached to the Istituto Ellenico in Venice, with splendid items, albeit almost all by Cretan masters. In Kuopio in Finland visitors to the Orthodox Church museum will find mostly late Russian icons, gainst a background of vestments and liturgical utensils.

The icon museum in Frankfurt am Main, opened in 1990, is a collection of Russian icons which is currently supplemented by items on permanent loan from the Staatliche Museen zu Berlin. The Berliner Museum was, incidentally, the first German institution to acquire icons, namely in 1821, while the Schlossmuseum in Weimar and the Lindenau Museum in Altenburg have small but interesting stocks of icons from early collections. We should not forget the large but little-known collection of Greek, Russian and oriental icons as well as other items of Orthodox art gathered by Prince Johann Georg von Sachsen

1730–1734 — production of "Mount Athos painters' book" ("Hermeneia")
1787–1792 — Russo-Turkish war **1812 — start of Napoleon's Russian campaign**

20. SIMON USAKOV

<u>Mandylion</u>
1658, egg tempera on wood, 55 x 48 cm
Moscow, Tretyakov Gallery

21. ALEXEI VON JAWLENSKY

<u>Meditation IX/35</u>
1935, oil on board, 18,5 x 13,4 cm
Dortmund, Museum am Ostwall

(1869–1938) on his travels and now housed in the Landesmuseum Mainz.

All of the last-mentioned collections however are surpassed by the Ikonen-Museum in Recklinghausen in the Ruhr. The unusual idea of forming such a collection in the then colliery town developed from an exhibition of a hundred icons from West German private collections in early 1955 in the Städtische Kunsthalle (municipal art gallery). It attracted an unexpectedly large number of visitors. As a result the then director of the Kunsthalle and organizer of the exhibition, Thomas Grochowiak, was extremely interested when the two leading icon collectors in Germany, Martin Winkler and Heinrich Wendt, offered to sell their collections to the gallery. On 21 July 1956, 18 months after the exhibition, the Ikonen-Museum was opened.

It houses by far the largest and highest quality icon collection outside the Orthodox countries. It can boast of being the only icon museum in the world that offers visitors not just a regional selection, but a collection ranging across the whole geographical and thematic spectrum of icon art. Well over a thousand icons, gold embroideries, miniatures, wood and metalwork from Russia, Greece and the Balkans, as well as an important collection of Romanian reverse-glass icons, give an impressive overview of the countless subjects and stylistic develop-

ment of icon-painting and small-scale religious art in the Christian East. Thirty-five exquisite works from the collection of the museum, with accompany descriptions, are presented in the second part of the current volume.

1917 — February Revolution: Tsar Nicholas II abdicates; October Revoltion in Petrograd: Bolsheviks seize power in Russia

THE DORMITION of the Mother of God

Egg tempera on wood, 90.3 x 67 cm
Recklinghausen, Ikonen-Museum

The feast of the Dormition of the Mother of God is the most important feast of the Virgin in the Eastern Church, in spite of the fact that it has no basis in the gospels. At first it was celebrated on various dates, but in c. 600 Emperor Maurikios finally stipulated that it be held throughout the Byzantine empire on 15 August. The feast and its associated images had their sources in apocryphal stories and homilies, among which a sermon on the death of the Mother of God by Archbishop John of Thessaloniki (610–649) had the greatest influence on the iconography.

As the Orthodox Church distances itself from the notion of the bodily assumption of the Virgin Mary, the emphasis in the depiction of this event is on the reception of her soul into heaven. Following the end of the Iconoclastic periods, the 10th and 11th centuries witnessed a compositional scheme that was largely retained and later only slightly altered or enriched by the addition of further scenes. This compositional scheme is also followed on the icon in Recklinghausen, which was doubtless painted in the west of Russia in the early 14th century, and represents the earliest item in the collection of the Ikonen-Museum.

The body of the Mother of God is lying stretched out on a bed parallel to the plane of the picture, her legs to the right, as is usual, and her arms crossed over her breast. The apostles, miraculously gathered by angels to the death-bed of the Mother of God from the locations of their respective missions, stand in two groups around the head and foot of the bed. The left-hand group is led by St Peter, who is swinging a thurible while moving his other hand, covered by a corner of his garment, to his face in a gesture of mourning. John, who was particularly close to Mary, is bending down towards her shoulder. On the right, Paul, wearing a long black beard, is pointing towards the event. Grief-stricken, he rests his head on his hand. The other apostles are also expressing their grief through restrained gestures.

Apart from the twelve apostles, there are two bishops in the house of the Mother of God, the structure of which is hinted at by architectural elements with pointed gables in the background. As there are no inscriptions bearing their names, they cannot be identified with certainty.

In the centre, behind the bed, we see Christ in a bluish mandorla crowned by a cherub. He is about to entrust to an angel the soul of his mother, represented as a haloed infant in swaddling clothes, which he is holding on his arm.

In front of the red curtain falling from the Mother of God's bed is depicted a scene which is likewise taken from a legend: a Jew named Jephonias had hurried to the scene in order to upset the bed of the Mother of God and disturb the solemn proceedings. At this moment, the legend recounts, there appeared an angel who struck off both of his hands with his sword. Only when Jephonias, on Peter's advice, had said a prayer to the Mother of God were his hands once more miraculously joined to his arms.

This scene is depicted predominantly on patron-icons which were placed on the Local Tier of an iconostasis, in other words the row of pictures representing the saints or feasts to which the church was dedicated. The relatively large format of this particular icon also speaks in favour of one of these as its original location.

As there are only a few Russian icons dating from this early period, and as a result hardly any examples for comparison, it is no easy task to assign this one to a particular region.

УСПЕНИЕ ІС ХС СТЫЯ БЦА
МИХАИЛЪ ГАВРИЛЪ

Luke paints the icon of the Mother of God Hodegetria

Egg tempera on wood, 26.4 x 18.3 cm
Recklinghausen, Ikonen-Museum

The legend according to which the evangelist and apostle Luke is said to have painted the first icon of the Mother of God was first mentioned in the treatise on the *Veneration of Holy Icons*, which has been attributed to Andrew of Crete (8th century). He is said to have written the text, which is based on older traditions, shortly before the outbreak of Iconoclasm, during which time legends about the existence of original portraits of Christ and the Mother of God played a major role in legitimizing the painting and veneration of icons. The text mentions that Luke painted Christ and His Mother with his own hands and that their images were kept in Rome and Jerusalem. The first images allegedly painted by Luke appeared in Constantinople and Rome during the 11th century, but it was only towards the end of that century, in an anonymous English travel report, that the icon of the Mother of God Hodegetria, venerated in the Hodegon monastery in Constantinople, which shows her carrying the child facing forwards on her left arm while pointing towards Him with her right hand, was referred to as St Luke's own work.

The oldest depictions in the visual arts of Luke painting the Mother of God can be found on two Byzantine miniatures of the 13th century. The icon in the Museum in Recklinghausen is probably the oldest representation of the subject in icon painting, where it is rare.

The saint is seated on a golden chair, applying the final brush strokes to the icon of the Mother of God Hodegetria, which is standing on a three-legged easel facing the beholder. He is evidently just painting the star on Mary's shoulder with shell gold. On the dark green floor is a paint box, a bowl with small shells, in which paints were mixed, and a bowl of water for rinsing the brushes. Two brushes have been inserted into holes in the easel's legs; they are there to allow the easel's height to be adjusted. The saint's name is written in Greek capitals on the icon's gold background. Research conducted in 1998 revealed that the tablet was part of a triptych or polyptych consisting of at least

eight images that was cut up into its individual components in 1963. There were always two scenes or images of a saint together, one above the other, so that the original work had a height of approximately 53 cm. In addition the panels were painted on both sides. Apart from the *Luke* in Recklinghausen, other works still extant include a very detailed *Crucifixion of Christ* in the National Museum in Stockholm as well as two panels, each with the *Prophets Solomon and David* and the military martyrs *Demetrius and Mercurius* in the Marianna Latsi collection in Athens. The current location of the four remaining images (*Baptism of Christ* as well as the *Harrowing of Hell, St Nicholas on the Throne* and *John with Prochoros*) is still unknown.

It is most likely that the work contained at least two more wings with the evangelists Matthew and Mark and additional festival scenes, but the issue of the original programme and the polyptych's extent has not yet been settled.

All of the depictions exhibit a strong relationship to Palaiologian models, not only in their elegant style with slender figures, bright highlights and detailed representations of the scenes, but also in the iconography that goes back to Byzantine works. The type of polyptych, too, where two scenes are represented one above the other, is exclusive to the late-Byzantine period.

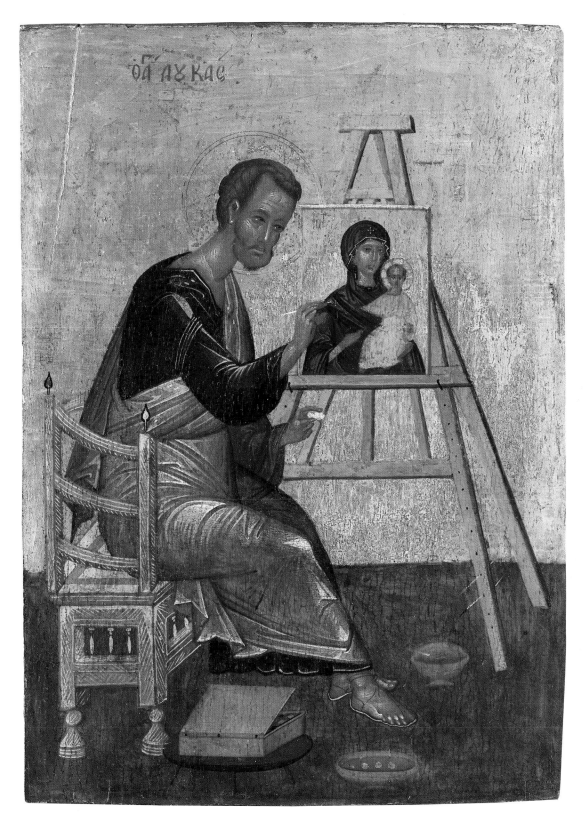

тhe Lamentation of christ christ with the мother of god and st catherine

Egg tempera on wood, each 42.5 x 109 cm
Recklinghausen, Ikonen-Museum

The icon is painted on both sides and is in a narrow horizontal format, indicating that it was originally attached above the royal doors of an iconostasis. The front depicts the Lamentation of Christ, which is closely related to the Deposition from the Cross and Entombment, but which is not mentioned in the gospels. This subject only found its way into art relatively late, namely in the 11th century, the fresco painted in 1164 in the church of Nerezi near Skopje containing the most impressive example. Besides the greater emphasis placed on Christ's humanity at this time, the development of this image owed much to the hymns and ceremonies of the liturgy of Holy Week. On Good Friday a cloth (epitaphios; ill. below) embroidered with the scene of the Entombment or Lamentation is carried to the centre of the church in a ceremonious procession and laid down for the veneration of the faithful.

The representation on the icon's front side shows the dead body of Christ, naked apart from a loin cloth, lying on a pink-coloured marble slab, where He is being mourned by His Mother, who is holding her son's head on her lap and has placed her face to His cheek. John the evangelist, in the middle, and Joseph of Arimathea are bent over the deceased, while Nicodemus on the right of the icon is leaning on a ladder. To the far left Mary Magdalene, dressed in the bright red gown,

Russia, Epitaphios (Plascanica), c. 1600

her hair loose, is sitting on the ground, throwing her arms into the air in grief. Full of pain, two further pairs of women look on the dead body of Christ. The three small hovering angels in front of the golden background are also expressing their grief through their gestures. The icon, painted in the best Palaiologian tradition, displays not just a balanced composition, but also a very nuanced modelling of the faces with dense, small highlights on the dark background, with precise contours and geometrically styled gowns in bright colours: all typical traits of early Cretan icon painting. A detail unusual for an icon, and one that is a sure sign of Italian influences, can be found in the bottom left corner. There the icon's donor is depicted on a smaller scale. He is painted in profile kneeling in prayer, facing the group of mourners. He is dressed in a long black gown and wears the tonsure. He has placed his head covering on the ground next to him. Unfortunately no donor inscription has survived. Possibly it went missing when the icon was cropped on all four sides.

The reverse, in reference to a Deësis, shows Christ between the Mother of Good and the great martyr Catherine, who replaces John the Baptist. This indicates that the icon was a donation to the daughter-foundation in Herakleion of St Catherine's monastery on Sinai. A mix of styles characteristic of Cretan icon painting can clearly be recognized: while the Mother of God and, in the centre, Christ blessing with both hands follow the best traditions of late-Byzantine art, St Catherine has been painted after Italian models: this applies not just to her gown and the palm branch in her left hand as a sign of her martyrdom (only customary in the West), but particularly to the representation of her face, which has been modelled with soft transitions in contrast to the other two faces, where parallel, fine white lines indicate the highlights.

The icon was doubtless painted by one of the best Cretan artists of the second half of the 15th century.

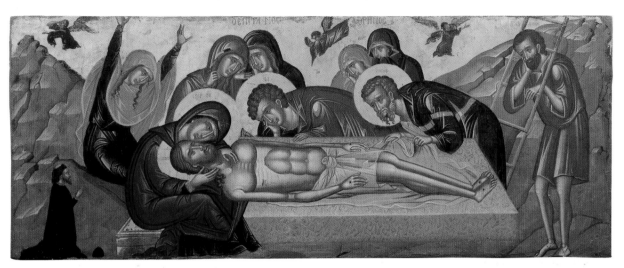

Royal Door

Egg tempera on spruce, 116 x 59 cm
Recklinghausen, Ikonen-Museum

The double door was the central entrance of a templon (an ico-nostasis) and once led to the sanctuary (bema). What is striking is the shape of the door with its twice-curved ogee arch, a feature that is known neither from Byzantine nor Russian royal doors. During the By-zantine period, double doors with a round arch were customary. They replaced the curtains which had previously been used to cover the entrances to the templon. The oldest examples still extant, in monasteries on Athos (Protaton and Hilandar), date back to the second half of the 10th century. Until far into the post-Byzantine period, the predominant motif re-mained the Annunciation, some-times in combination with Peter and Paul, or other saints, in the lower area.

The royal doors from Reck-linghausen are part of a group of doors that can be dated to a period from the second half of the 15th century to the 17th century. The feature they have in common is their shape, which tapers off sharply to the top, and the double curve of the arch. It resembles the Gothic ogee arches which we are familiar with from Venetian architecture and also from Vene-tian buildings on Crete. In many cases the ogee arches are decor-

Andreas Ritzos (?), Royal Door, 2nd half of 15th century

ated with free-standing acanthus leaves carved into the curvature, which however only survive in fragmentary form. The carved beading where the doors meet is also missing. In most cases this central rod ends in a cross or a painted medallion surrounded by tendrils.

However, what is completely unusual and probably unique about this door are the images painted on it over a gold background. The top left image shows the Archangel Michael in armour holding a raised sword, the top right image depicts Gabriel holding a staff and a sphai-ra (orb), on which the image of Christ Emmanuel is inscribed. Both archangels have been painted from the front, showing only their upper bodies. Painted on the door's lower zone are the abbot Saint Zosimas and the ascetic hermit Mary of Egypt. They are represented at the mo-ment when Zosimas administers communion to the former prostitute as a sign of forgiveness; she had atoned her sins as an anchorite in the desert for 47 years. In his left hand Zosimas is holding a chalice half covered by a red cloth. He is giving the ascetic, shown in profile with her hands raised in supplication, a small spoon with the communion. This subject seems so well suited for a door leading to the altar that we have to ask ourselves why it was painted only on this one bema door.

The royal door was painted by an excellent Cretan icon painter of the second half of the 15th century. Stylistic analogies with the door of the church of St Georgios Aporthianon on Patmos (ill. left) most likely created by Andreas Ritzos (c. 1421–1492) and with other icons signed by or attributed to him suggest that this significant artist was also the painter of the royal door in Recklinghausen. His work, as well as that of the painter Angelo, served as a model for subsequent generations. This was also the case in the representation of Zosimas and Mary of Egypt. Although they do not appear on a royal door anymore, they can be seen on an icon dated 1603 and signed by Emmanuel Lambardos (Provid-ence, Rhode Island Museum of Art), which was doubtless based on the same model as the royal door in Recklinghausen.

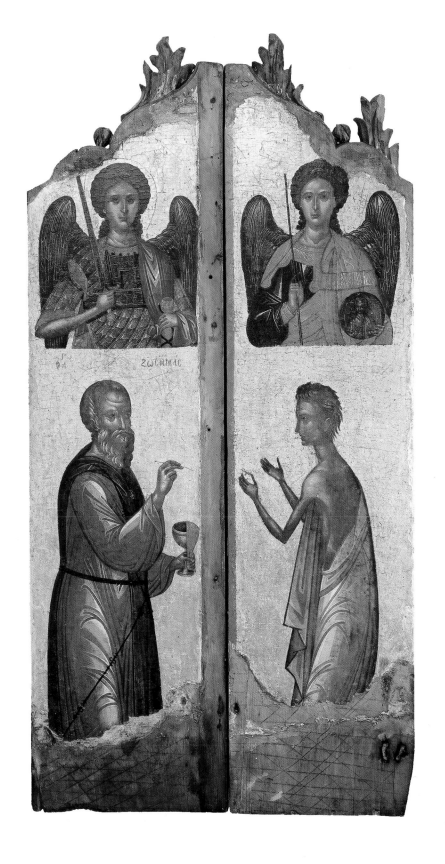

THE ANNUNCIATION

Egg tempera on wood, 31 x 25.5 cm
Recklinghausen, Ikonen-Museum

The feast of the Annunciation of the Virgin, which is celebrated on 25 March (exactly nine months before the Nativity of Christ), has been one of the major feasts of the Church from early on. The moment in which Mary acquiesced in God's resolution to actively participate in the salvation of mankind is considered the moment of Incarnation, the moment the Word became flesh.

The basic formula of this subject's representation underwent little variation in the art of the Eastern Church. It is based on the Gospel of Luke (1:26–38) and the apocryphal Gospel of James (chapter 11) and shows the dialogue between the approaching Archangel Gabriel and Mary, who is either standing or sitting.

The icon in Recklinghausen, whose central panel is slightly set back, also shows Gabriel and Mary standing, facing each other. The archangel is stepping towards Mary in a long stride, one arm reaching out to her, while she has stood up from her seat and is calmly listening to the angel's words, her head bowed in humility. In his left hand Gabriel is holding a staff, identifying him as a heavenly messenger. Mary is holding a spindle with purple thread, because according to the tradition of the Gospel of James she was one of the virgins chosen to weave the curtain for the temple in Jerusalem. Her right hand is extended towards the angel from the folds of her garment almost as if she were trying to ward him off. With this gesture she is expressing her fear of the message which Gabriel is proclaiming, namely that she was the one chosen to carry the divine Logos in her womb. Towering up in the background behind Gabriel and Mary are two tall, grey buildings that are oriented in the same direction as the two people in the foreground. The buildings are connected by an olive-green wall with narrow, rectangular niches. As a symbol of the divine conception the dove of the Holy Spirit is coming down on to the Virgin from a small piece of sky between a tree in the centre and the pediment of the building behind her. The inscription is no longer extant.

Despite the vitality of the hurriedly approaching archangel, the icon emanates solemn calm. Contributing to this effect are not only the self-contained silhouettes of the buildings in the background and the statuesque figure of the Mother of God, standing upright, but also the muted, harmoniously chosen colours standing out from the golden background. Through the dramatic brightening of the garments draped in the classical manner, the artist has achieved a three-dimensionality of the bodies that is characteristic of late-Byzantine painting, the period during which this icon was created. However it is not just from a stylistic perspective that the icon in Recklinghausen has its roots in Palaiologian painting; the iconography of the Annunciation, too, as can be seen on this icon, was developed during the 14th century and became a prototype for a whole number of Cretan icons from the second half of the 15th century.

The Recklinghausen Annunciation has particularly close parallels to icons by Nikolaos Ritzos and his father Andreas, for example the Annunciation on the Icon of the Deësis, bearing the signature of Nikolaos Ritzos (c. 1460–1503), with ten festivals as well as saints, was located in Sarajevo, or the icon, now in the Benaki Museum in Athens, attributed to the circle of Andreas Ritzos, with the Mother of God on a throne with two angels, surrounded by four festivals and fourteen saints. These significant similarities suggest that the Recklinghausen icon was created in the Ritzos workshops.

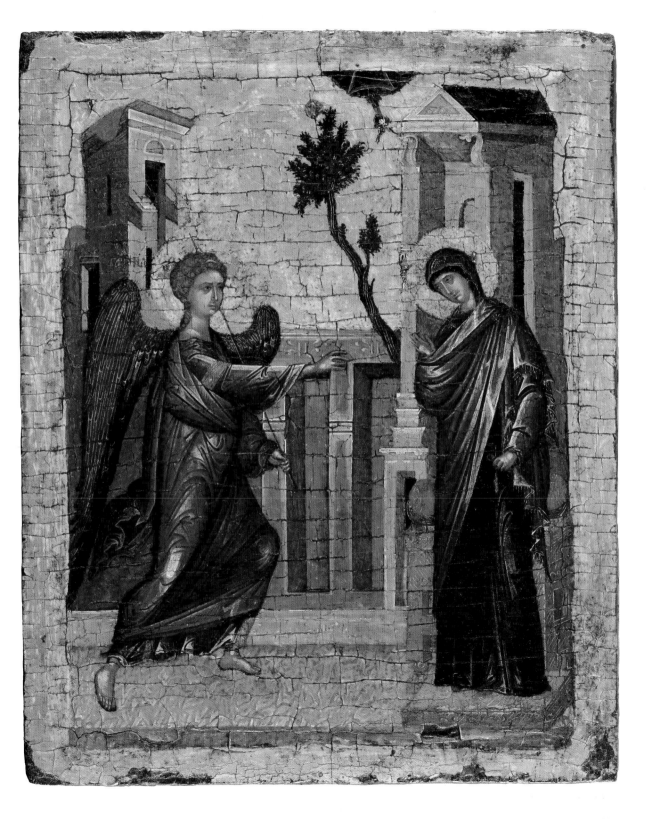

THe Apostle Peter

Egg tempera on wood, 89 x 44 cm
Recklinghausen, Ikonen-Museum

Among the twelve apostles, Simon Peter (= "rock") was the one who was always by Jesus's side, and who had the closest relationship to him. In the list of apostles, he is named first (Matthew 10:2), and Jesus Himself said of him: "Thou art Peter, and upon this rock I will build my church." (Matthew 16:18–19)

Born in Galilee, Peter originally made his living as a fisherman in Capernaum, where together with his brother Andrew he was called by Jesus to be His disciple. He was condemned to death by crucifixion in Rome (where he was preaching at the same time as Paul) under Emperor Nero in 64 or 67 CE. Constantine the Great had an imposing basilica built above the site of his grave in 324; this church was replaced by the current St Peter's Basilica consecrated in 1626. Peter is venerated in the whole Christian world, and together with Paul is regarded as the organizer of the Christian Church.

The oldest Russian icon in the Museum of Novgorod shows him together with Paul and dates from the 11th century. Most often, though, he is shown on Deësis icons, which occupy the most important tier on the iconostasis. The term "deësis" means "supplication" or "intercession" in Greek, and relates to the prayers of the Mother of God, John the Baptist and other saints on behalf of mankind. Christ was always painted in the centre, flanked by the Mother of God and John the Baptist. On either side the archangels Michael and Gabriel were added, along with martyrs, hierarchs and ascetes. Usually, St Peter and the Archangel Michael are represented behind the Virgin, while Gabriel and St Paul are on the same side as John the Baptist.

The icon illustrated here comes from such a deësis; it depicts the apostle Peter, and comes from the collection of Alexandre Popoff, who emigrated to Paris in the wake of the October Revolution. St Peter had been conventionally shown since the 4th century with a broad, roundish face, a short grey beard and short curly hair. He is shown in three-quarter profile facing right, and, his head slightly bowed and his right arm raised, is taking a step towards Christ in the middle of the Deësis Tier. In his left hand he is holding a closed scroll tied with a red ribbon. Over the dark-green undergarment or chiton, he is wearing an ochre himation in the classical fashion, which he has thrown over his left shoulder, leaving his right arm free. The halo is gilded, and the background painted a very pale ochre, against which the name in red uncials stands out. The broad dark-green strip of floor is patterned with diagonal strokes and simple stars, characteristic of a fair number of Novgorod icons of the second half of the 15th century and early 16th century. Particularly icons of the second half of the 15th century evince close iconographic, stylistic and colour similarities with the icon of St Peter in Recklinghausen, which differs from them only in the slightly squatter figure of the apostle. All comparable icons follow the same model, and differ only in whether the scroll held by the apostle is open or closed, and whether or not he is shown with a key, his characteristic attribute.

"while the existence of icon centres and schools is inconceivable without the background of a church organization, it is not always slavishly bound up with it."

Konrad Onasch, 1995

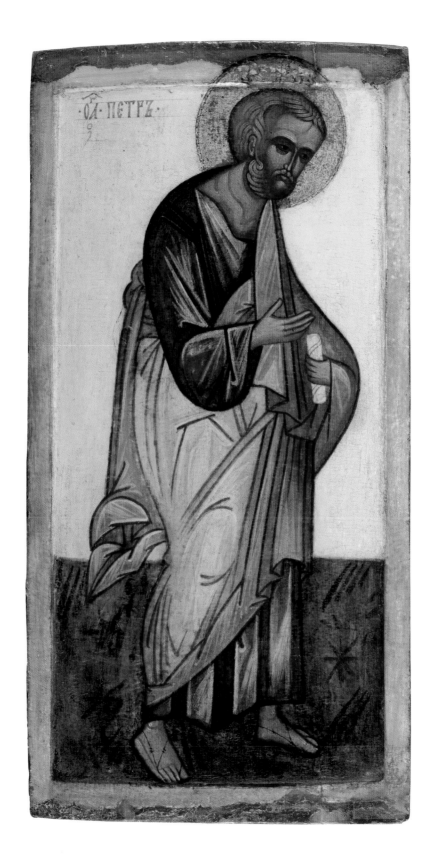

ОА ПЕТРЪ

christ in the тomb

Egg tempera on wood, 64 x 49.5 cm
Recklinghausen, Ikonen-Museum

An icon depicting Christ standing in the open tomb should be seen not as narrative, but as symbolic in character. He stands in front of a black cross in a pink sarcophagus, which conceals the lower part of His body up to the hips, which are covered by a loin-cloth. His head, the eyes closed, has fallen on to His right shoulder, the hands with the stigmata are crossed at waist-level. To the vertical of the cross has been affixed a paper, rolled in at the ends, with the abbreviated words Ο ΒΑΣΙΛΕΥΣ ΤΗΣ ΔΟΞΗΣ (The King of Glory), which are taken from the Good Friday liturgy. Angels are flying towards Christ from both corners of the picture, expressing their grief in different gestures. Into the horizontal of the cross, at the level of Christ's shoulders, three nails have been hammered. This corresponds not to Orthodox, but to Western tradition, according to which Christ's feet were fastened to the Cross with just one nail.

The representation of the dead Christ in half-length is derived from the Deposition, the Lamentation or the Entombment, and known in Byzantine art from as early as the 12th century. It belongs in the context of the liturgy of Holy Week, but also in that of the eucharist, which was interpreted as the mystical slaughter of the sacrificial lamb, i.e. as the Crucifixion. For this reason, the motif of Christ standing in the tomb is often to be found in the prothesis, the left-hand sanctuary, of Byzantine churches, in which the holy eucharist is prepared. From about 1300, Christ was shown with hands crossed, as prescribed by the funeral rite. This is how he is to be seen on the famous Byzantine mosaic icon, measuring just 19 x 13 cm, in the Roman church of Santa Croce in Gerusalemme; it too is dated to this period, and arrived in Rome in 1385/86.

In the 15th century a further variant appeared in Crete, popularized especially by the icons of Nikolaos Tzafoures, a Cretan artist who is mentioned in documents between 1487 and 1500, and in almost all of whose works strong trecento influences are apparent. On the icons sig-

ned by or attributed to him, Christ holds His hands not crossed in front of his body, but displays them, and the stigmata, with outstretched arms. Typical of the style of Nikolaos are the gently illuminated monochrome modelling of the body of Christ, the precise depiction of the hair and the Crown of Thorns, and the pattern of the halo. Not only the outspread hands and the Crown of Thorns are Western elements, but also the perspective depiction of the sarcophagus.

By contrast, the Recklinghausen icon, which dates from approximately the same time, is painted in a style and technique which accord with the traditions of late-Byzantine art. As can be recognized particularly well in the angels' garments, several pale elements are placed in layers above the dark underpainting for the purpose of modelling, the pigments of the main colour being mixed with increasing quantities of white. The uppermost layer consists of pure lead white. The body of Christ and the faces derive their volume from white strokes placed in parallel. But the fact that there are three nails, which flies in the face of Orthodox tradition and the central perspective of the sarcophagus depiction would, like the patterned halo, be unthinkable without the Italian influences (ill. left).

**Filippo Lippi, Imago Pietatis (detail),
c. 1430**

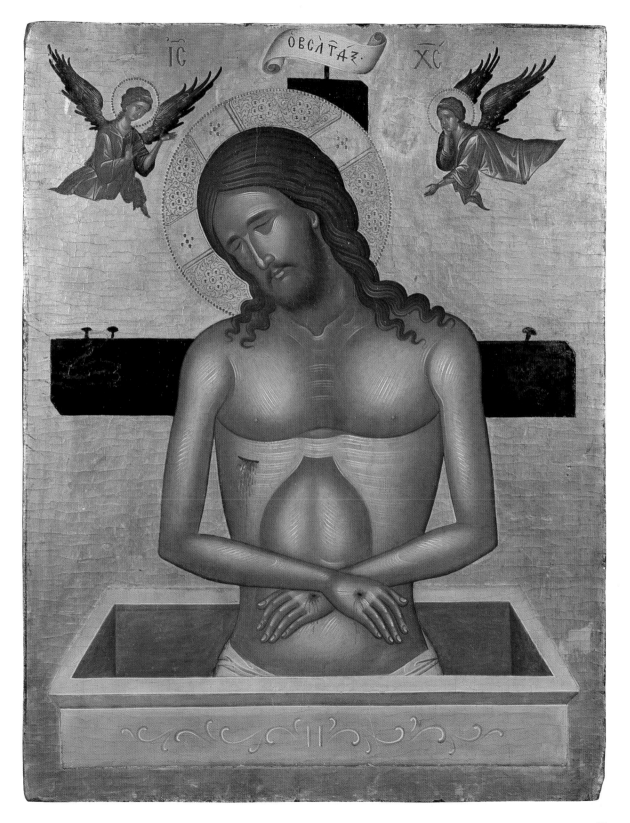

st Nicholas with scenes from his Life

Egg tempera on wood, 92.5 x 71 cm
Recklinghausen, Ikonen-Museum

St Nicholas is one of the most popular Christian saints, both in the West and in the Christian East, but very little is known about his life in the way of historical fact. According to tradition, he was born the son of prosperous parents in Patras (Lycia) in about 270, and died in about 342. He was bishop of Myra in Lycia on the south coast of Asia Minor, and may have attended the First Ecumenical Council at Nicaea in 325, which was concerned with whether the Father and the Son were of one substance. But there is no proof of whether he was there, for his name is not on the list of those present. Because of the large number of miracles attributed to him, Nicholas is highly venerated, and called upon by believers in every conceivable distress.

The Byzantine Church venerated Nicholas from as early as the 6th century, especially in Myra and Constantinople. With the christianization of Kievan Rus' from the end of the 10th century, the cult of St Nicholas was also introduced to Russia, where it spread unusually strongly, with numerous churches being dedicated to him. After the relics of St Nicholas were forcibly removed from Myra (now under Islamic control) to Bari in southern Italy in 1087, his cult witnessed a major upturn in the West too.

In the art of the Eastern Church, Nicholas is always depicted in bishop's garments and with a short, white beard and hair; a characteristic feature is an almost impossibly large forehead, signifying his unusual wisdom. Nicholas always wears the omophorion, the distinguishing episcopal vestment, and holds the book of gospels, likewise the characteristic episcopal insignia.

As early as about 1200, the half or full-length figure of the saint in the centre of the icon was surrounded on the margins by scenes from his life and the miracles he had worked. The earliest known biographical icon is in St Catherine's monastery on Mt Sinai. From the early 14th century, numerous biographical icons of Nicholas were painted in Russia too, more than of any other saint.

In Russia several versions of the St Nicholas image were known. The type we see on the illustrated icon is known as "Nicholas of Zaraysk". Characteristic of this icon is that Nicholas has his arms spread in prayer, the book of gospels in his left hand. This version got its name from the village founded by Yuri in the place where he had encountered the icon, which had been brought in 1225 from Khersones in the Crimea to the region of Ryazan. The depiction symbolizes the idea of intercession and protection by the saints and is in the great majority of cases surrounded by scenes from his life.

This is also true of the icon in the Ikonen-Museum, which was painted in northern Russian province of Novgorod towards the end of the 15th century. Nicholas is depicted full-length against a red background, which was originally covered by a metal mounting as can be deduced from the numerous nail-holes and the remaining nails. Clothed in the episcopal vestments in the form of a polystaurion embroidered with many crosses, he is depicted on the model of the icon in Zaraysk. His life and miracles are represented on the 14 marginal fields.

Nicholas rescues seafarers in distress

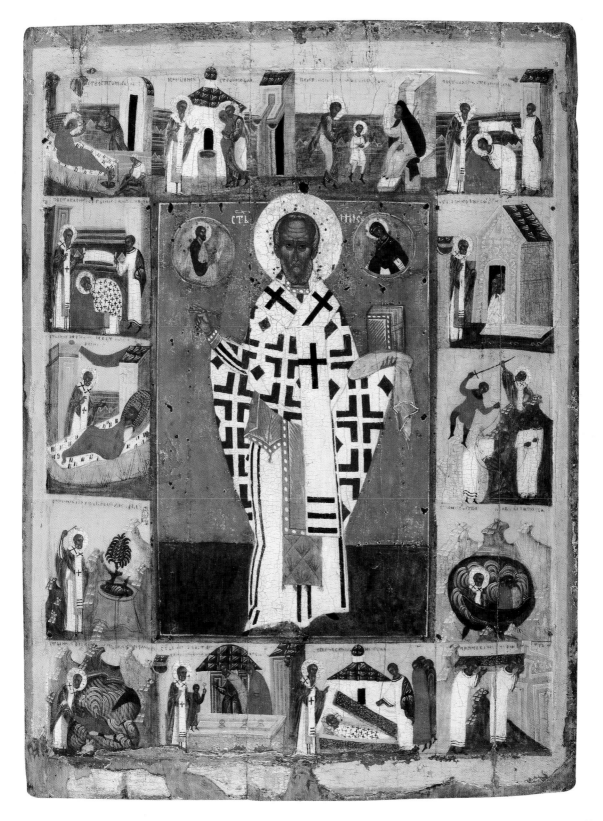

Exaltation of the cross

Egg tempera on wood, 48 x 36 cm
Recklinghausen, Ikonen-Museum

The theme of the icon is the Feast of the Exaltation, or Raising Aloft, of the Cross, which is celebrated annually at the Orthodox Vespers on 14 September. It commemorates the legendary "Invention" or Discovery of the True Cross by Helena, the mother of the Emperor Constantine, which is said to have happened on that day in the year 320. It was linked, additionally, with the feast of the dedication of the Church of the Holy Sepulchre (Anastasis Basilica), erected by Constantine above the empty tomb of Christ, the site of His Resurrection. According to the *Menologion* of Basileios II (vat. gr. 1613), written between 976 and 1025, it was on the day after the consecration, which took place on 13 September 335, that the people of Jerusalem first had the opportunity to see the True Cross relic preserved in the church, the bishop having presented the Cross while the congregation cried out "Kyrie eleison!" On 14 September 614, the ceremony of the Exaltation of the Cross took place for the first time in Constantinople too. In 635 Emperor Herakleios finally had the relic of the Cross brought thither, Jerusalem being in danger of falling to Omar's troops. This was five years after he had re-captured it from the Persians, who had plundered it in 614.

Presentation of Christ, late 15th century

Not long after, the festival was also introduced to Rome, where it was mentioned for the first time under the pontificate of Pope Sergius I (687–701).

In the cycle of Russian festival images, the representation of the Exaltation of the Cross has had an important place since the 16th century, the icon in Recklinghausen probably being one of the oldest Russian depictions of this theme.

The Exaltation of the Cross is represented on the icon in a solemn, strictly symmetrical composition: against the background of a massive round church with "Russified" onion domes, which is supposed to depict Constantine's Rotunda of the Anastasis, the centre of the icon features Bishop Makarios of Jerusalem on a large, two-stage ambo (a kind of pulpit) with a semicircular rear wall. Assisted by two deacons, he holds aloft the relic of the Cross. The festival is attended by Helena and Constantine on the right-hand side, and a group of singers in characteristic full-length garments and the head-covering known as the scaranica. The depiction is in the laconic style characteristic of Novgorod, confining itself to essentials, and preferring a bright, limpid coloration, in which dark green, a luminous vermilion dominate alongside white and ochre.

The icon was originally part of the Feast-day Tier of an iconostasis, in fact together with another icon in the collection, which depicts the *Presentation of Christ in the Temple* (ill. left). Two further icons (*Trinity* and *Transfiguration*) are in the Korin collection in Moscow, and a fifth showing the *Nativity of John the Baptist* in the Blackburn Museum and Art Gallery in England.

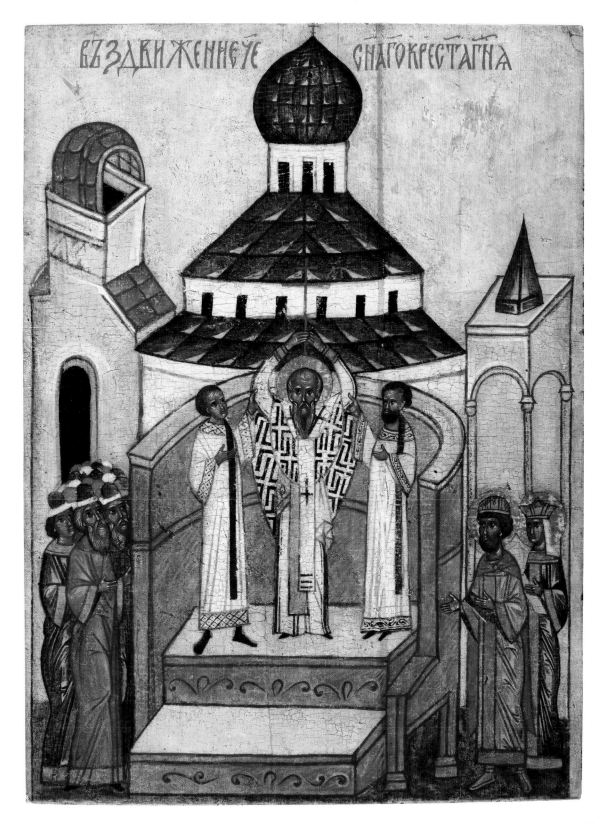

madre della consolazione

Egg tempera on wood, 46.5 x 37.7 cm
Recklinghausen, Ikonen-Museum

Towards the end of the 15th century, a new kind of Mother-of-God icon appeared in Cretan icon-painting. It quickly became very widespread and remained extremely popular with artists and patrons until well into the 17th century. This type is known as the "Madre della Consolazione" (Mother of Consolation) and is distinguished by a striking Italian influence. As in many Italian paintings of the Madonna, we find the fine, diaphanous veil beneath the maphorion (overdress) of the Mother of God instead of the Eastern cap or bonnet. Western too is the way the garment of the Virgin is fastened over the breast with a clasp, and the incuse patterning of the haloes. Typically Venetian is the opulent golden pattern of the Virgin's garment, which can be seen in similar form on many Venetian trecento paintings, especially those by Paolo Veneziano and his successors. The Christ-child is holding an open scroll with the (in places heavily abbreviated) Greek inscription ΠΝΕΥΜΑ ΚΥΡΙΟΥ ΕΠΓΕΜΕ; ΟΥ ΕΙΝΕΚΕΝ ΕΧΡΙΣΕΝ ΜΕ ("The Spirit of the Lord GOD is upon me; because the LORD hath anointed me"). The gospel of Luke (4:18) reports that in the synagogue in Nazareth, Jesus opened the scriptures at this passage (Isaiah 61:1), in which the prophet in the name of God proclaims the mission of mercy and loving-kindness to those in exile, promising them speedy deliverance, relating these words to Himself when he went on to comment (Luke 4:21): "This day is this scripture fulfilled in your ears."

It is not known whether these Western-oriented Mother-of-God icons were in fact primarily conceived for a Catholic public. A second variant of the "Madre della Consolazione" in particular could suggest this: here, the Christ-child is holding not the scroll with the Greek quotation, but a golden orb, which is unusual in Byzantine icon-painting. The "invention" of this hitherto unknown Mother-of-God type is attributed to the Cretan painter Nikolaos Tzafoures, as until the 17th century there are no "Madre della Consolazione" icons signed by any other painter. According to Cretan documents preserved in the Venetian state archives, Nikolaos Tzafoures (Nicolaus Zafuri) was first mentioned in 1487 in Candia (today's Herakleion) in Crete, where he lived and worked until about 1500. Little is known about the life of this painter, who was a contemporary of Andreas Ritzos and Andreas Pavias, and in almost all his signed works painted "alla latina", including purely Catholic themes. Apart from two icons with the depiction of the dead Christ between the Virgin Mary and St John the Evangelist in the Kunsthistorisches Museum in Vienna and the State Russian Museum in St Petersburg, as well as a *Christ Carrying the Cross* in the Metropolitan Museum in New York, there is a *Madre della Consolazione*

Nikolaos Tzafoures, Madre della Consola-zione, before 1500

signed by Nikolaos Tzafoures in the Kanellopoulos collection in Athens, and another in a private collection in Triest. A third icon in the Byzantine Museum in Athens, on which Christ is turning to St Francis of Assisi standing beside Him, is also attributed to him. Not until 1999 was his (Latin) signature also discovered on a "Madre della Consolazione" icon in private ownership, which is now on permanent loan in Recklinghausen (ill. left).

The Mother of God of the Passion

Egg tempera on wood, 82 x 61.5 cm
Recklinghausen, Ikonen-Museum

The icon with the motif "Mother of God of the Passion" was extraordinarily popular in the Cretan icon-painting of the late 15th and the 16th century, and is venerated both by Orthodox and by Catholic Christians.

This type takes its name "Mother of God of the Passion" from the fact that the Christ-child, sitting on the left arm of His mother, is turning towards the Archangel Gabriel, who is depicted floating in from the right holding out a Cross. From the other side the Archangel Michael approaches, holding further symbols of the Passion, the Spear and the Holy Sponge. The Christ-child is fearful at these auguries of death, and clings to the right hand of His mother. The frightened movement causes one of His sandals to become dislodged from his right foot. Below the angel with the Cross can still be seen the remains of a four-line Greek inscription, whose translation reads: "Before presenting his greetings to the Spotless One, he [the Archangel Gabriel] shows him the Instruments of Passion; Christ though, having become mortal flesh, looks at them in fearful horror." This explanatory inscription can also be found on some icons in Latin, obviously depending on the denomination and origin of the icon's owner.

The models for the later Cretan version of the Madonna of the Passion can be recognized on the fresco in the church of Panhagia tou Arakou near Lagoudera in Cyprus, which dates from 1192. The Mother of God, designated as "Arakiotissa" stands before a throne and holds the semi-recumbent Christ-child in her arms. As in later "Mother of God of the Passion" images, she is approached by angels holding the Instruments of the Passion on either side. But it was not until the 15th century that the fully developed type of the Madonna of the Passion became widespread through numerous icons by the Cretan icon-painters. Possibly the "invention" or at least the popularization of this icon type is due to the important painter Andreas Ritzos, who was born in Candia (today's Herakleion) in Crete in about 1421, and died there

after 1492. Three signed *Madonnas of the Passion* by him are known; today they are in the Galleria dell'Accademia in Florence, the Galleria Nazionale in Parma and in the church of St Blaise in Ston (Dalmatia). The painting style of these signed icons corresponds so closely to that of the *Mother of God of the Passion* in Recklinghausen as to allow an attribution of the latter to Andreas Ritzos too. In all the icons, a striking feature is the perfect technical execution, and the smooth surfaces of the flesh depiction, which are modelled by a large number of delicate, parallel white brush-strokes.

This icon type very quickly also became popular in the Catholic West, in particular in southern Italy and Venice. The famous Catholic miracle-working icon of *Our Mother of Perpetual Succour* is likewise of Cretan origin; when the island was besieged by the Turks it was taken first to Ostia. In 1865 it was presented by Pope Pius IX to the Redemptorist church of San Alfonso on the Esquiline in Rome, whither it was taken in solemn procession. Since 1866 the Vatican has despatched countless "authentic" copies of the image, which as a result has a place in almost every Roman Catholic Church. On 23 June 1867, it was solemnly crowned, and in 1876 received its own festal service, which is celebrated in Redemptorist churches on the Sunday preceding 24 June.

"To thee as the fount of goodness we sing prayerfully in hymns with voices of thanks."

From the Marian hymns of Theophanes Graptos, d. 845

st menas of egypt on horseback

Egg tempera on wood, 27.3 x 22 cm
Recklinghausen, Ikonen-Museum

St Menas is Egypt's most important saint. He is said to have been born there, served as a soldier in the Roman army, and to have acknowledged his faith in Phrygia during the persecution of Christians under Diocletian, being beheaded in consequence. But the numerous witnesses to his life, martyrdom and miracles, which have been handed down in many languages, are contradictory. Legend reports that in fulfilment of his wish, his comrades brought his body back to his Egyptian homeland in a coffin. There, the relics were buried in a small shrine at the place where the camels, for all their efforts, could no longer move the coffin from where it lay. This shrine, known as Karm Abu Mena is located to the west of Alexandria, and soon attracted large crowds of pilgrims. Small clay vials with his picture as a souvenir for pilgrims were distributed in extraordinary numbers. The heyday of the location as a pilgrimage site, one of the most important in early Christendom, ended with Bedouin attacks in the 9th century, which resulted in the decay and eventual total disappearance of the buildings. Subsequently the veneration of St Menas fell into oblivion, before being revived by the miraculous re-discovery of the grave in the 14th century.

In the early iconography Menas is not depicted and venerated as a warrior saint, but as a martyr, to whom healing powers were ascribed. The first representations of the saint armed and in soldier's armour can be found in Serbian churches, e.g. in the church of the Holy Apostles in Peć, whose interior paintings date from about 1290. Depictions of St Menas on horseback were however unusual throughout the whole Byzantine era, and even in post-Byzantine times, i.e. from the 15th century, he is only very seldom depicted thus. The relatively small icon in the Ikonen-Museum Recklinghausen may well be the earliest on which the saint was shown as a warrior on horseback. Menas is riding a white horse, which is walking at a measured pace. The saint is in armour and wearing a general's red cloak. In his right hand he is holding a long spear, there is a sword at his side, and he is

carrying a round shield on his back. In line with late and post-Byzantine tradition, he is depicted as middle-aged, with grey curly hair and grey beard. The saint is shown in an attitude rarely seen, namely sitting astride his horse, but with his torso turned frontally to the beholder. This type stands in the tradition of the Adventus representation of the Roman emperors, emphasizing the display and triumphal aspect of the image.

The icon is very delicately painted, the coloration exquisite and balanced. The gold ground, the vermilion of the wafting cloak and harness form, along with the pearl-grey of the horse a triad of particular charm.

The dating of the icon to the late 15th or very early 16th century rests on a comparison with other representations of warrior saints in Cretan painting, primarily as regards the form of the armour and the depiction of the horse, the manner in which the face is painted, and the profiled frame, which in this form is almost only ever found in 15th-century icons.

This very high-quality picture of a saint was probably painted for an aristocratic patron, as an icon of his own patron saint, by one of the best Cretan icon-painters of his day.

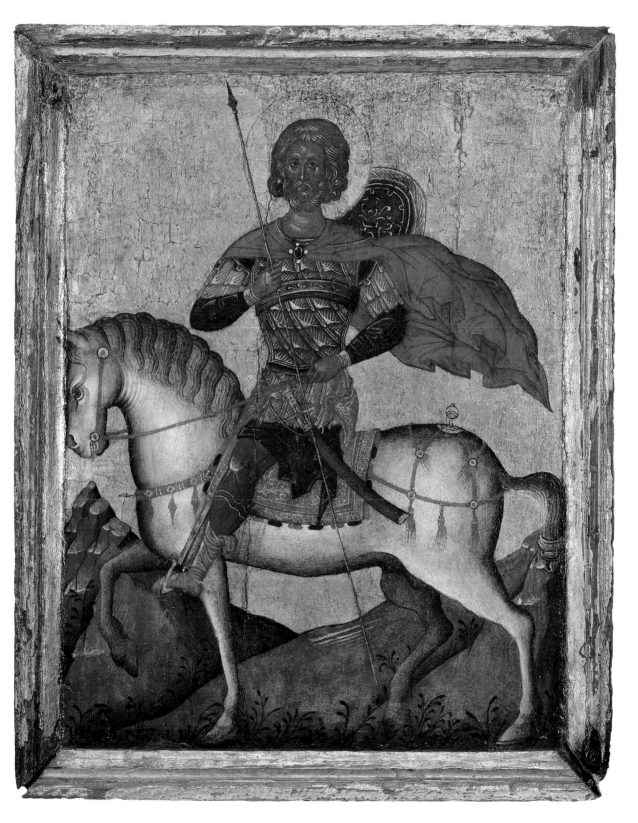

Doubting Thomas

Egg tempera on wood, 81.5 x 51.5 cm
Recklinghausen, Ikonen-Museum

At the centre of this icon, described in large red uncials as the "Examination of the Ribs of the Lord by Thomas", is Christ with His right arm raised, surrounded by two groups of apostles. He is looking at Thomas, who is taking a long stride towards Him and placing his finger in the bared wound in His side. Behind Thomas, eight apostles are crowding in as they watch the scene with astonishment. On the right-hand side by contrast are just three disciples: Peter with his hands raised in prayer, and two others. Behind Christ a tall centrally planned building looms, dominating the upper half of the icon. Christ is emphasized by the nave of the church with its ogee arch, and the cupola with a golden lantern. The dark doors of the building point to the doors of the room having been closed when Christ appeared to the apostles. The rotunda is flanked on either side by the salmon-coloured walls, the rising section on the left emphasizing the dynamics of Thomas's movement. The central building has a bluish-green tiled roof, which contrasts both with the ochre of the walls and with the gold ground of the icon. In the figures' garments, blue and green hues are dominant, albeit enlivened here and there with a bright red.

The depiction is based on the passage in St John's gospel (20: 19–29) which tells of Jesus' appearance among His disciples on the ninth day after His resurrection, and the doubts expressed by Thomas, who had not been present when the risen Christ first appeared to them. The iconography of Doubting Thomas is known from the 5th/ 6th century and has undergone no significant changes since. From the 15th century icons with this motif were included in the Russian feast-day tier, the first examples including the icon from the iconostasis of the Cathedral of the Dormition in the Kirillo-Belozersky monastery dating from c. 1497 and the icon from the church of the Holy Trinity in the monastery of St Paul of Obnora (now in the State Russian Museum in St Petersburg) which was painted in the Dionisii workshop in about 1500. The icon in Recklinghausen shows great similarities in the ar-rangement and attitude of the figures with that from the Kirillo-Belozersky monastery, differing however in the coloration, the background buildings and the fact that Christ is depicted as taller than the apostles, and, moreover, stands on a suppedaneum (pedestal) and is thus emphasized. The suppedaneum and the ascending wall to the left, and even the clover-leaf pattern on this wall, are however to be found on the icon from the St Paul of Obnora monastery.

The superbly painted and well preserved icon in Recklinghausen was also once part of the Feast-day Tier of a large iconostasis. Nailmarks in the gilt ground and on the edges of the two longer sides of the somewhat cropped icon indicate that it was once decorated with silver fittings.

"with his hand/seeking the confirmation of faith/тhomas explored /thy life-giving side."

From the Thomas Sunday hymns

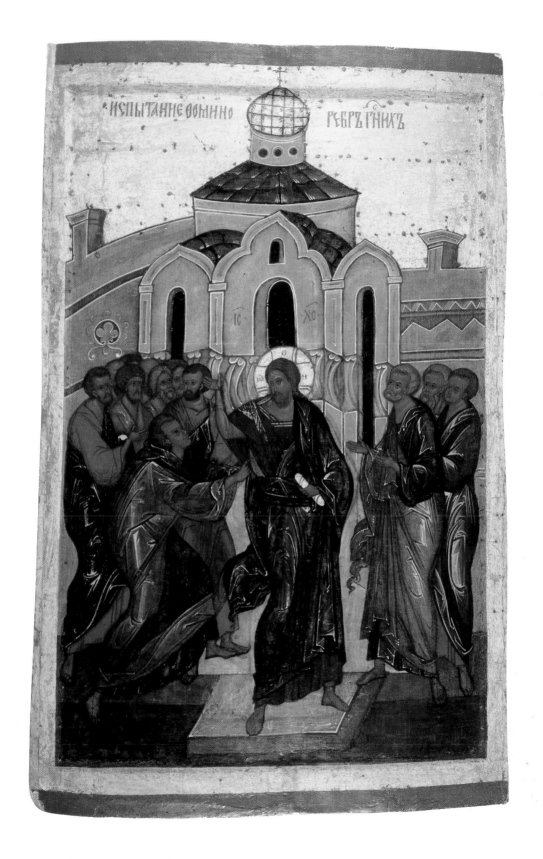

ИСПЫТАНИЕ ѲОМИНО РЕБРЪ ГНИХЪ

st George and the Dragon

Egg tempera on wood (set in a new panel), 31.5 x 26.5 cm
Recklinghausen, Ikonen-Museum

As the protectors of soldiers, as well as their holy comrades-in-arms in combat with enemies, the warrior saints were among the most popular and most frequently depicted saints. They are shown either as martyrs in a long chiton and a chlamys with a cross in their right hand, or else as warriors in armour. Some of them are depicted for preference on horseback, a style thought to be modelled on Egyptian or Thraco-Dacian equestrian deities. Alongside St Demetrius of Thessaloniki, St George is one of the most popular equestrian saints.

George originated from Cappadocia, and served as an officer in Emperor Diocletian's army. He was tortured for his openly acknowledged Christianity, and beheaded in 303. As there are no reliable data concerning his life, his biography is based entirely on legends.

It was not until the 11th century that this biography was enriched by the story of the dragon, but it soon became one of the most popular motifs in icon painting, whether in the form of the combat between George on horseback and the dragon, or as a more detailed depiction of the legend of the rescue of the daughter of King Selbius, who was due to be sacrificed to the dragon. After it had been subdued by the saint, she led the monster on her girdle into the city. Often the fearful inhabitants are depicted watching the fight with the dragon from the towers and city walls.

St George, first half of 14th century

The painter of this icon limits himself to the fight itself, in other words the symbolic depiction of the victory of good over evil. Sitting as usual on a white horse, George, represented as youthful and beardless, plunges a long lance into the mouth of the dragon, which is snaking out of a cave beneath the horse's rear right hoof. This cave is compositionally and symbolically intended as the counterpart to the section of heaven in the top left-hand corner, and, with the lance, the saint's right arm and leg, and the line from the rear right hoof via the horse's back, forms the diagonal in the picture's structure. The icon, which was painted in the early 16th century, was transferred to a new panel (Russian: *vrezka*), presumably during the 19th century, probably because the old one had become worm-eaten. The original gold ground has been lost, but for a few fragments, so that the figure of the saint now stands out against an ivory-coloured ground. The icon is distinguished by its delicate draughtsmanship and the balanced use of bright colours, among which a brilliant vermilion, the white of the horse, and the green in the saint's garment enter into a harmonious combination with the ochre of his armour and of the rocks in the background.

The cult of St George as great martyr and "victor" was widespread at an early date in the Byzantine empire. His veneration reached its peak in Cyprus, Cappadocia, Georgia and the north of Russia. The Crusaders brought his cult to the West, where he has been patron saint of England since 1222, and is accounted one of the Fourteen Helper Saints in Germany. His feast day is 23 April.

Among the earliest depictions of St George and the Dragon in Russia are a 12th-century fresco in St George's church in Staraya Ladoga and a biographical icon dating from the first half of the 14th century in the State Russian Museum in St Petersburg (ill. left).

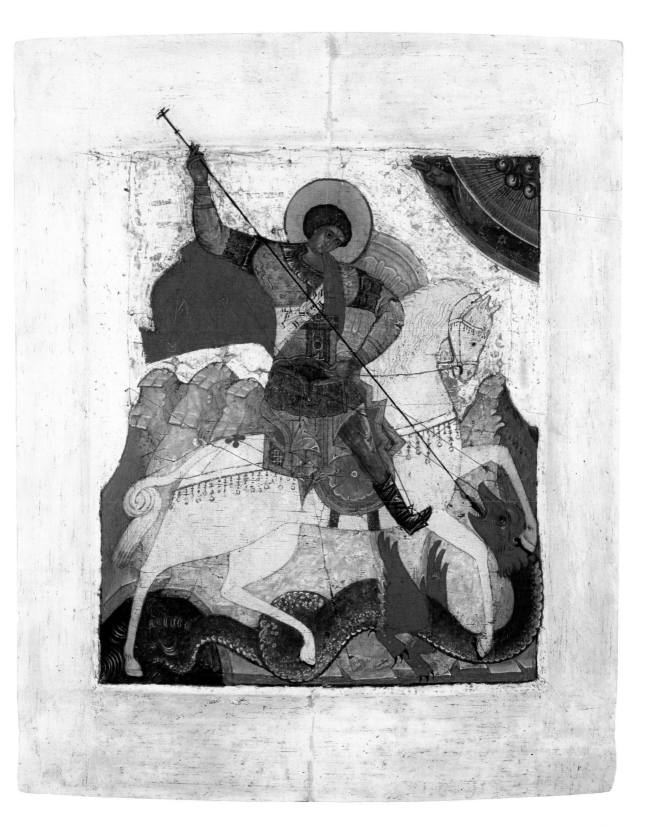

Resurrection of Christ and the Harrowing of Hell

Egg tempera on wood, 131 x 104.2 cm
Recklinghausen, Ikonen-Museum

Easter is the high point of the liturgical calendar and for this reason the Easter image is accorded a central position in the decoration of churches with mural paintings or mosaics, as well as in the iconostases, where the Easter icon is an established part of the Feast-day Tier. The large icon in the Ikonen-Museum in Recklinghausen, however, did not form part of any Feast-day Tier, but was without any doubt the dedication icon of some "church of the Resurrection", and thus placed in the Local Tier of the iconostasis.

The Easter stories in the gospels do not describe the moment of the Resurrection from the tomb directly, but only through the message conveyed by the angels. For this reason the belief expressed in the Creed ("He was crucified, dead and buried, and descended into Hell"), Christ's descent into the realm of the dead, is celebrated as the central moment of His victory over death and Hell (cf. I Corinthians 15:45f.). Since the 7th century at the latest (cross reliquary in the Metropolitan Museum, New York) it was the actual Resurrection image of the Eastern Church, and gradually came to replace the depiction of the women at the tomb which had been usual since early-Christian times. Only from the 17th century, when Western art began to exert a strong influence on Russian and Greek painting, did the Resurrection of Christ from the tomb, or Christ hovering above the tomb, make its appearance in icon painting. The pictorial representation of the Descent into Hell (or the Harrowing of Hell) is based on the apocryphal 5th-century "gospel of Nicodemus", which illustrates it in graphic detail.

In a halo of light, which in this icon is represented as a pale-blue mandorla, Christ appears in a luminous white garment. He is standing on the gates of Hell, the two wings of which are laid crosswise one over the other, torn out when Satan refused to open the gates of the underworld to Christ. The fragments of the locks and keys of the gates of Hell are falling into the darkness of the abyss. With His right hand, Christ grasps Adam by his wrist, and pulls him from his grave. To the right, Eve, the mother of mankind, kneels behind Christ in a red garment, raising her respectfully shrouded hands in prayer. The two figures in regal attire behind Adam are David and Solomon, who are being presented by John the Baptist, the last of the prophets. Between them can be seen the head-dress of a further prophet, probably Daniel. Behind Eve stands Moses with the tablets of the law in his hands, in conversation with two more ancestors, the younger of whom can probably be identified as Abel, the older perhaps as Isaiah. Above Christ's mandorla, two angels are holding the Cross and the Chalice, symbolizing that Christ's sacrificial death is the precondition for the salvation of humanity.

The composition of this monumentally conceived icon is carefully balanced. It is determined by the two diagonals. The attitude of the rising Adam, the outstretched arm of Christ and the fluttering tip of His white garment (continued in the steeply rising rocks), underscore the diagonal which begins bottom left. Its counterpart is emphasized by Eve's red garment and the upper body of Christ inclined to the left. The highly elongated figures with small heads, along with the pale palette, are characteristic of Russian painting in the early 16th century.

"Thou hast descended into the depths of the Earth and shattered the eternal locks which held captive the tormented, o christ, and on the third day, like unto Jonah from the monster, thou hast risen from the grave."

6th ode of the Easter Night liturgy

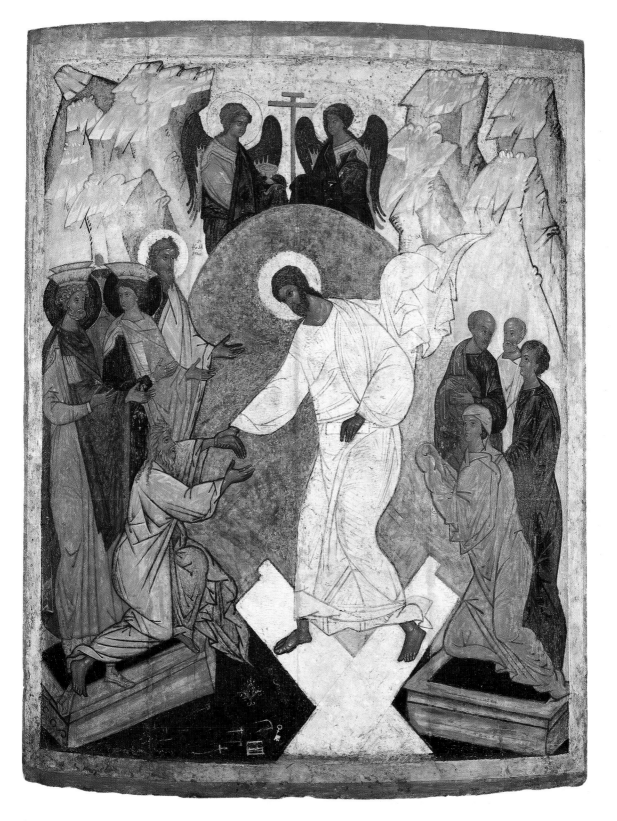

ᴛʜe saints and ꜰeasts of the church calendar

Egg tempera on wood, each 157.9 x 90.5 cm
Recklinghausen, Ikonen-Museum

Every day of the Church year is dedicated to the memory of one or more saints or to a feast which commemorates an important event in the life of Christ or His mother. While it is fairly common to find depictions of all the saints and feasts commemorated in a particular month, it is rare to see the whole Church year painted on one or two panels. The earliest example of a complete calendar in the form of a diptych is in the collection of St Catherine's monastery in Sinai. The two 12th-century panels (which each measure no more than 36.5 x 24.6 cm) contain depictions of more than 1200 figures from the festal calendar.

The oldest Russian example may well be the large two-part icon in the Ikonen-Museum Recklinghausen, which was painted, probably in Moscow, in the 16th century. The Orthodox liturgical year comprises two cycles of festivals: one of movable feasts based on the lunar calendar, and another, whose dates are fixed, based on the solar year. The saints and feasts of the latter are depicted in ten rows on each panel, in precise chronological order, starting on the left-hand panel with 1 September and ending on 14 March, and continuing on the second panel from 15 March to 31 August. The start of the cycle of immovable feasts on 1 September relates to the calendar introduced in Byzantium in the 7th century, which began with the Creation on 1 September 5507 BC. A red dot (representing the moon) marks the start of each new month. The movable feasts, based on the lunar calendar and centring on Easter, which can fall on any date between 22 March and 25 April, are depicted on the second panel. These movable feasts (from the Raising of Lazarus via Passiontide, Easter, the Ascension and Whitsun to All Saints, celebrated on the first Sunday after Whitsun) are difficult to integrate into any perpetual calendar; were brought together by the artist in the two central rows on the picture. All the saints and feasts are provided with a date and (unfortunately not always preserved) name, one day in appropriate cases being represented by more than one saint. Their clothing allows the saints to be assigned to certain categories, such as prophets, apostles, martyrs, monks, deacons, bishops, rulers and physicians. In addition, each saint is characterized by age, style of hair and beard, and other such features as were handed down in pattern drawings and descriptive books for painters.

Although the depiction of several hundred saints next to each other carries with it the danger of monotony, the painter of this icon has succeeded in composing each figure individually, achieving considerable variety in the garments, attitudes and faces (p. 9). It is possible that the second panel was painted by a different artist, as the figures are more crowded and also the quality of the first six months is not quite achieved.

It has been suggested that these unusual panels might have been painted to mark the canonization of numerous Russian saints at the Council held from 1547–1549. However, very few of the Russians canonized on that occasion are represented (Procopius of Ustyug, Leonty of Rostov and Mikhail of Chernigov); this, together with the absence of other important saints, makes a post-Council dating very unlikely indeed. The style of the icon also supports an early 16th-century date.

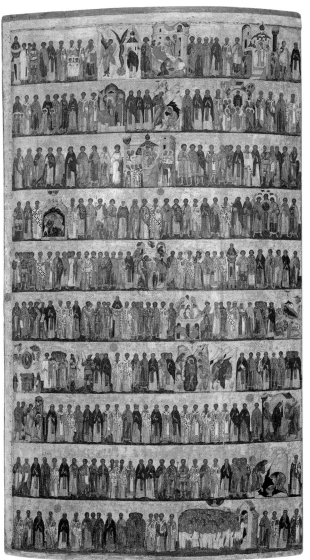
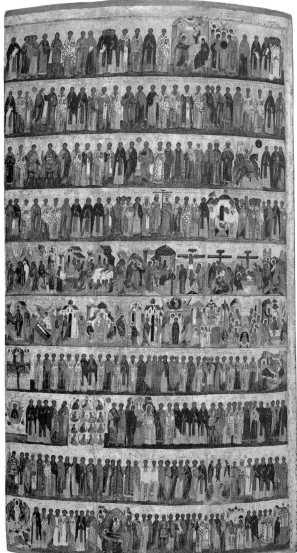

The Nativity of christ

Egg tempera on wood, 55.5 x 34.5 cm
Recklinghausen, Ikonen-Museum

The representation of the Nativity of Christ rests not just on the accounts found in the gospels of Matthew and Luke, but also on apocryphal narratives from the Protoevangelium of James and of Pseudo-Matthew. To start with, Christmas was celebrated on the Feast of the Epiphany, 6 January, but it was transferred in Rome to 25 December, the winter solstice, in 354. Just as in the Roman Empire this day was celebrated to mark the re-birth of the sun god, sol invictus, the Christian Nativity festival glorified the advent of the son of God.

The icon of Christ's Nativity unites a number of events related to the Christmas story on a narrow rectangular panel. It was without a doubt painted for the Feast-day Tier of an iconostasis. The composition follows a widespread Greek iconography, already to be seen on a 14th-century fresco in the Peribleptos church in the Greek town of Mistra.

The picture is structured by a steep, rugged rocky massif on which can be seen isolated bushes. The rocks open up in the middle to reveal a cave, in which we see a basket-like crib with the newborn infant in swaddling clothes. An ox and an ass are bending over the crib in line with the words of the prophet Isaiah (1:3). The Mother of God is depicted lying outside the entrance to the cave on a luminous red cushion, clothed in a maphorion (over-garment), which, contrary to the tradition of the Eastern Church, is blue. She is supporting her head on her right arm, while watching two maids preparing a bath for the child. The young woman standing at the left of the picture is pouring water from a pitcher into a round basin. It is no coincidence that this resembles a baptismal font, for the postnatal bathing of the Christ-child was seen as a pointer to His baptism. The midwife, sitting to the right of the basin, is holding the child in her lap, while testing the temperature of the water with her hand. With his back to all this, Joseph is sitting on a rock, his head supported on his hand in contemplative manner. He is talking to an aged shepherd in a blue skin cloak. The latter is some-times interpreted as a tempter, seeking to awaken in Joseph doubts concerning the Virgin Birth. At the top right, an angel is proclaiming the birth of Christ to another shepherd, whom we see from behind, while on the left, the three Magi are riding up on their horses. In line with Western tradition, the astrologers are represented as kings. They are guided by the Star of Bethlehem, to which the angels singing praises top left are also turning.

The coloration of the icon is notable in particular for a luminous red and blue. Together with the pink of the garments of some of the angels and the seated midwife, these colours form a cheerful contrast with the ochres of the rocky landscape and the gold of the background. The painter was evidently acquainted not only with the traditions of Byzantine icon painting, but also with Italian art. This is indicated by his realistic animal depictions, the rear-view figure unusual in icon painting, and the composition of the muscular arms of the maids and legs of the shepherds. These are characteristic stylistic features of icon painting on Crete under Venetian rule, where this example was probably painted.

"Today: the virgin bears/the Lord in the interior of a cave. ... Today: the whole of creation is jubilant/and is joyful, for christ is born/of the virginal maid."

From the Marian hymns for the Nativity of Christ

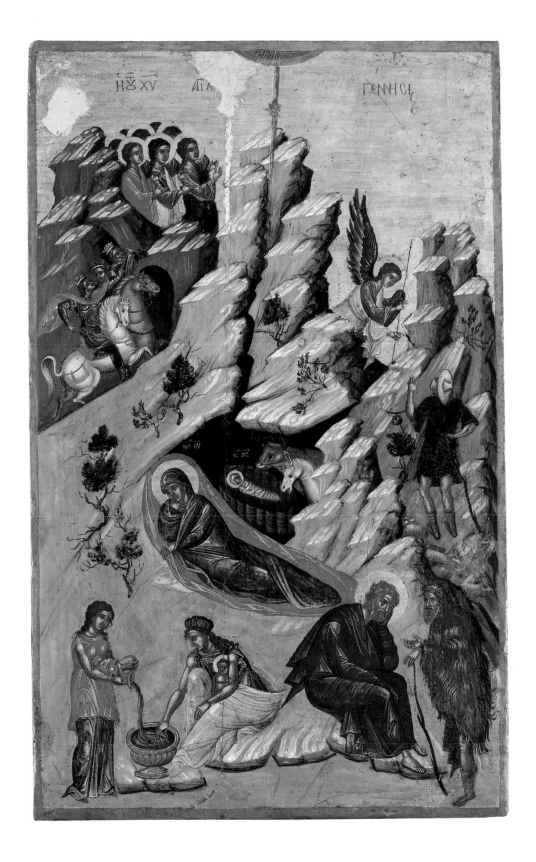

mandylion

Egg tempera on wood, 71 x 58 cm
Recklinghausen, Ikonen-Museum

Mandylion is the name given to an image of Christ, which, unlike other such images, was not formed by human hand, but miraculously created by an imprint going back to Christ Himself. The term goes back to an Arabic word, *mandil* or *mindil*, which means cloth or towel, thus indicating the material of the picture. This textile picture is also known as an Abgar picture, as legend relates that Christ sent King Abgar V Ukkama of Edessa (9–46) a messenger with the image of his countenance on a cloth, in order to cure him of a serious illness. According to legend, under Abgar's grandson, who was not a believer, the cloth was immured by the bishop for safe-keeping above the city gate. Not until the siege of Edessa by the Persians under their ruler Khusrau I in 544 was it re-discovered as a result of a vision by bishop Eulalios, thus helping the city to victory. In 944, the Byzantines brought the important relic to Constantinople after negotiations with Edessa and the Arabs who by then ruled the city. Thereafter the Mandylion occupied a pre-eminent place among the holy objects of the Byzantine Empire, being kept in the church of the Mother of God in the imperial Bukoleon Palace. In the chaos following the occupation of Constantinople by the Fourth Crusade in 1204, the Mandylion disappeared. Several cities in western Europe subsequently claimed to have it within their walls. For example, until the French Revolution it was said to be in the Sainte-Chapelle in Paris, but also in St Peter's in Rome (and from there, according to the latest theories, to have got to the village of Manopello in the Abruzzi). By contrast, a different story has it being donated by the Byzantine Emperor John V (1332–1391) to the monastic church of San Bartolomeo degli Armeni in Genoa some time during the late 14th century.

Icons that reproduce the Mandylion show the portrait of Christ frontally and without neck or shoulders on the background of a cloth. The hair has a parting, falling to the shoulders on either side. Sometimes the cloth is shown being borne by angels in the corners of the picture. This is the case in this very striking Russian icon, which was quite clearly created by an important icon-painter in the second quarter of the 16th century.

Particularly interesting in this example is an inscription in Old Church Slavonic in a medallion on the reverse, which reads: "In St Petersburg in the year 7381 (= 1872) on 4 December, I, the great sinner Nikita, son of Sevastiyan Racheiskii from the province of Samara, restored this icon." This is the only known autograph of an (Old Believer) icon-painter mentioned several times in the works of the Russian writer Nikolai Leskov (1831–1895). Racheiskii is regarded as the model for the character of the icon-painter Sevastyan in the well-known story *The Sealed Angel*. Leskov mentioned that he had written the whole of this story in Nikita's "hot and stuffy workshop", in fact in the same year that Nikita was restoring the Mandylion icon there. It is not impossible that the icon even belonged to Leskov himself, as he is known to have had a collection of icons. Nikita's restoration measures are largely confined to the edges and the nimbus, while the face and the hair are original. The inscription at the bottom edge of the cloth, "The image, not made with hands, of our Lord Jesus Christ", was also added by Racheiskii.

Inscription on the reverse of the Mandylion

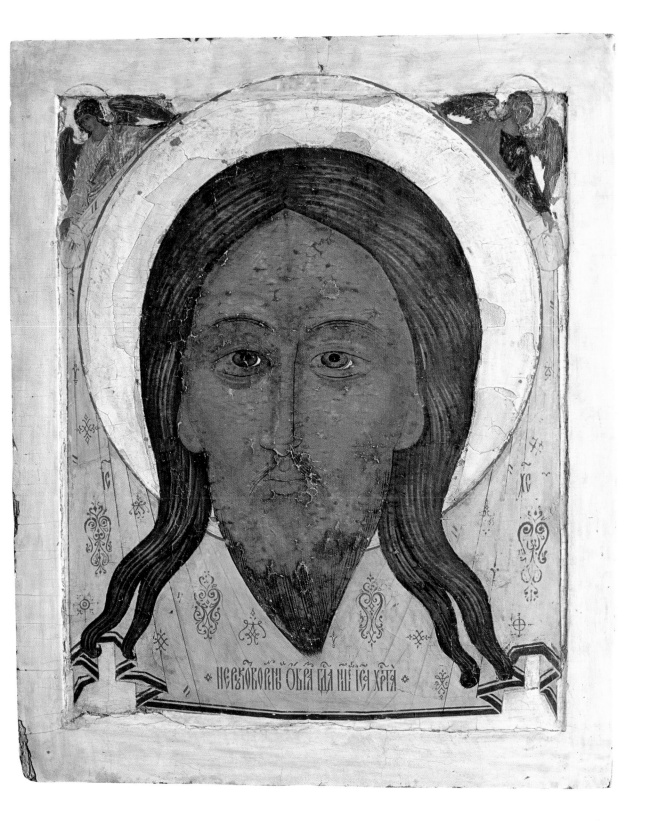

christ "The Never-sleeping Eye"

Egg tempera on wood, silver-gilt basma, 31.7 x 26.2 cm
Recklinghausen, Ikonen-Museum

==

The depiction shows the resting Christ Emmanuel (a type of the youthful Christ confined to the art of the Eastern Church) in the midst of a landscape paradise with trees, shrubs and birds. The young Christ, wearing a golden garment, seems – half sitting, half lying – to be hovering weightlessly over the green of the landscape, His body forming the diagonal of the picture, which is continued in the head of the Mother of God, who is standing on the left-hand side. She is approaching Him with hands raised in supplication. From the other side, the Archangel Michael is bending down towards the recumbent Christ. In his hands, which are shrouded in his luminous red tunic, he is carrying the Cross and other symbols of the Passion. On the pale ground of the picture is a two-line inscription with the title of the icon, "The Never-sleeping Eye", as well as the fourth verse of Psalm 120 (Psalm 121 in the Western reckoning), to which this is an allusion: "Behold, he that keepeth Israel shall neither slumber nor sleep." But this verse alone is hardly enough to decipher the complex content of this picture, which is why even at an early date other sources were linked to it, in particular the *Physiologus*. This is a popular book based on numerous materials dating from pre-Christian times, with short stories about the characteristics of real or fabulous beasts, trees and stones, to each of which the anonymous author adds a Christian interpretation, backed up by quotations from the Bible.

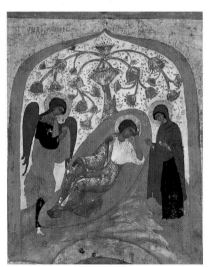

**Christ "The Never-sleeping Eye" (detail),
1st half of 17th century**

Physiologus begins with the lion as king of the beasts. He talks of the watchfulness of the lion, which led to the conviction that the lion slept with open eye. In addition, he relates this to the death of the incarnate Christ on the Cross, on the one hand, and to his immortality as God on the other, which gives this death the appearance of temporary sleep. *Physiologus* also goes into the expected Resurrection of the dead, sacrificial Christ.

Further sources relating to our theme can be found in the Old Testament comparisons of Judah to a young lion (Genesis 49:9; Numbers 24:9; Deuteronomy 33:20). As Christ was descended from the house of Judah, the lion as symbol is also transferred to Him. Thus the quoted texts help to explain why on depictions of the "Never-sleeping Eye" Christ is always shown as the youthful or even childlike Emmanuel: it is the young Lion of Judah, whose form He assumes.

On the icon of the "Never-sleeping Eye" the figure of the Mother of God is associated with the Incarnation of Christ. The Archangel Michael by contrast, with the symbols of the Passion in his hands, points to the sleep of death of Christ's body on the Cross, from which it will be resurrected by the Father, whose omnipresence is represented on the icon by the suggestion of Heaven at the top edge of the picture.

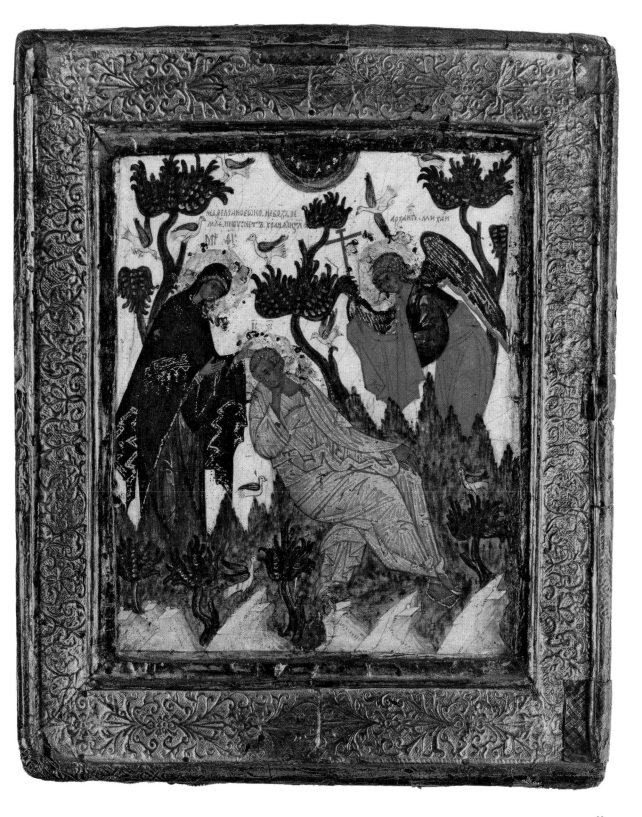

τransfiguration of christ

Egg tempera on wood, 76.5 x 51 cm
Recklinghausen, Ikonen-Museum

Among the oldest Church feasts of the Christian East is that of the Transfiguration of Christ on Mount Tabor, celebrated on 6 August; following the Iconoclastic dispute, it became part of the cycle of feast-day images. The Transfiguration, described by the evangelists Matthew (17:1–9), Mark (9:2–10) and Luke (9:28–36), at which, as on the occasion of His baptism, the divinity of Christ was made manifest, points to the Resurrection and to the Second Coming of the Lord in glory at the end of days.

This feast was depicted on the mosaic in the apse of St Catherine's monastery on Sinai as early as 565. The iconography here remained binding: the transfigured Christ stands in an aureole between the prophets Moses and Elijah, while the first three apostles to be called, Peter, John and James, throw themselves to the ground in fear, dazzled by the supernatural light.

We can see the same arrangement on the Recklinghausen icon. Christ is standing on a sharp rocky outcrop in a radiant white garment, as described in the gospels (Mark 9:3). Christ is giving the blessing with His right hand and holding a closed scroll in His left. He is surrounded by an oval aureole of light, in which is inscribed a rectangle with inwardly curving sides, from which rays emanate towards Elijah and Moses, each standing on his own mountain summit in an attitude of veneration. Three further rays strike the three disciples, who have thrown themselves to the ground in prayer. Peter is just getting to his feet once more, gazing up at the transfigured Christ in amazement. John is tumbling downhill head first, losing a sandal in the process. James, finally, seated on the ground, turns and shields his eyes from the blinding light with his hand.

To this basic scheme of the depiction of the event, this icon adds two others, which respectively precede and follow the Transfiguration. On the left, Christ is climbing the mountain with the three disciples, while on the right we see the descent, with Christ, His finger rai-

sed in admonishment, saying to His attentive listeners: "Tell the vision to no man, until the Son of man be risen again from the dead." (Matthew 17:9)

It is not known who painted this Transfiguration icon, but he must have been one of the best artists of his day. This is shown by the outstanding painting technique, with its skilful combination of cool colour tones of cerise and bottle green against the warm ochre and gold ground. The balanced distribution of the figures on the three planes, the highly vivacious and individual style of the faces and the realistic reproduction of the apostles' emotions show that this artist knew and implemented the Byzantine traditions very well, but was also highly familiar with Italian painting techniques. His own style is typical of the icon-painters working on the island of Crete, which was ruled by Venice. After the Fall of Constantinople, they continued the traditions of Byzantine art at a high level.

This *Transfiguration* shows particular affinities with the frescoes and icons of the Cretan painter Theophanes Strelitzas (c. 1500–1559). In particular, the icon from the Pantocratoros monastery on Mount Athos largely matches the Recklinghausen icon in its coloration and the style of the figures, in particular the apostle Peter.

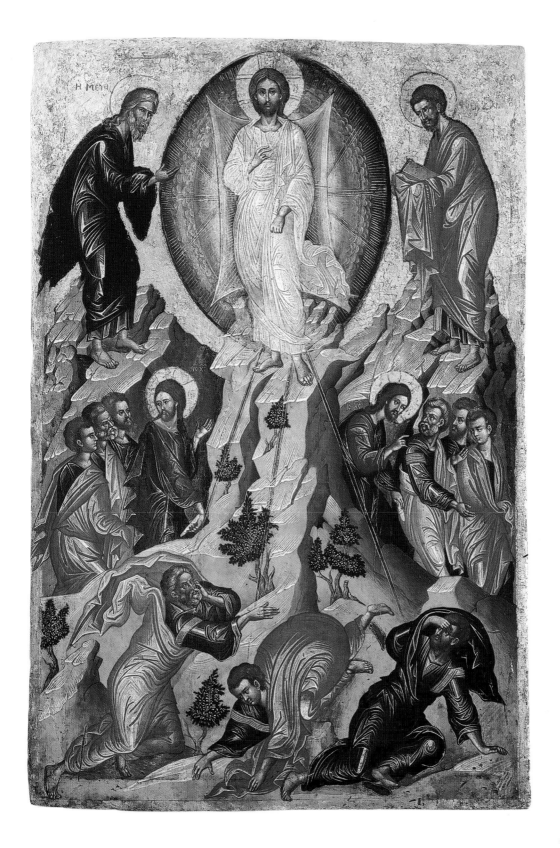

mother of god of vladimir

Egg tempera on wood, oklad with rosettes, haloes and decorative plate (cata) of silver filigree with enamel and semi-precious stones, 34.5 x 29 cm
Recklinghausen, Ikonen-Museum

After the Mother of God had been given the title "Theotokos" (God-bearer) at the Council of Ephesus, the third Ecumenical Council of the Church in 431, her veneration increased steadily. This is also reflected in the Mother-of-God icons, whose number far exceeds that of those depicting only Christ. And yet every Mother-of-God icon is also a Christ icon, for Mary is almost exclusively depicted either with the Christ-child, or else as intercessor before her son.

In the course of time, hundreds of different types of Mother-of-God icon emerged, especially in Russia. These are miracle-working images, differing in their depiction of the attitudes of Mother and Child, and, like saints, have feast days of their own on which they were venerated in the liturgy. Many of these icons have names linking them with the place at which they first appeared or worked miracles.

The most-venerated miracle-working Mother-of-God icon in Russia is the *Mother of God of Vladimir*, or *Vladimirskaya*. Like the famous Hodegetria, legend has it that it was painted by the apostle and evangelist St Luke. It arrived in Constantinople from Jerusalem in the 5th century and in about 1136 was presented by the patriarch of Constantinople to Kiev, where it was kept in the convent of Vysgorod. In 1155 Prince Andrei of Bogolyubovo (d. 1174) took the icon with him to Vladimir, the capital of the principality of Rostov-Suzdal. After the destruction of Kiev by the Mongols, Vladimir became the ecclesiastical, political and cultural centre of the Russian lands; it was here that Andrei resided from 1157 as Grand Prince, and to where the archdiocese of Kiev was transferred in 1300.

Twice the miraculous icon was taken to Moscow in order to save the city from besieging Tartar armies. On 26 August 1395, the precise day on which the *Vladimirskaya* was received by the Muscovites with great honours, the Tartar commander Timur Lenk (Tamburlaine) gave the order to retreat. On 23 June 1480, the *Vladimirskaya* went once again to Moscow, the new centre of the Russian empire, this time for good, for now it was being threatened by the Tartar khan Sultan Achmat, who was repelled thanks to the aid of the *Mother of God of Vladimir*. This ended the 250-year domination of Russia by the Tartars.

Until 1917 the *Vladimirskaya* was kept on the iconostasis of the Cathedral of the Dormition in the Kremlin in Moscow. From 1547, all the tsars were crowned in her presence, and from 1589 until the Revolution all the Russian patriarchs were also installed here.

In 1918 parts of the original painting (faces and background) were exposed following the removal of numerous overpaintings, and the icon was transferred to the Tretyakov Gallery, where it still is, albeit nowadays in a chapel dedicated to this national sacred object.

On the copy illustrated here, the Mother of God, as customary in icons of the Vladimirskaya type, is holding the Christ-child on her right arm, while pressing her cheek to the infant's head. Christ has thrown His left arm around His mother's neck, and is clasping at her shoulder with His right hand. Particularly noteworthy is the fine oklad (metal cover) with rosettes, haloes and a breastplate (cata) of blue, turquoise and green enamel, silver filigree and semi-precious stones.

> "тoday мoscow, the famous city, is decked out in festival mood, for she has received as the dawn, dear Lady, thy miraculous image, to which we hasten and call:
> o wonderful mistress, beseech christ, thy son, our god, that нe may preserve us and all christian lands from the deceits of our enemies, and, нe the merciful, save us all."

Troparion for the Feast of the Icon of the Most Holy Theotokos of Vladimir on 21 May, 23 June and 26 August

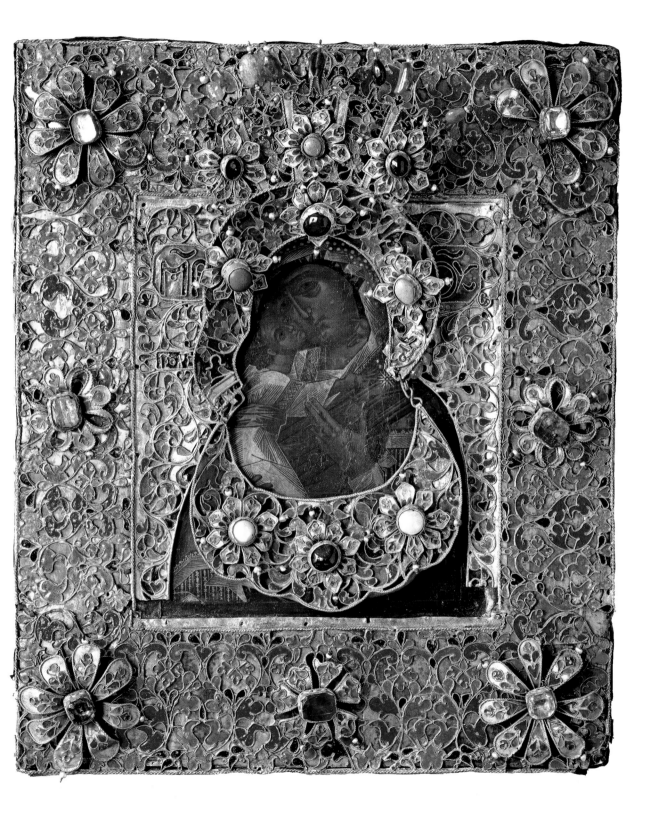

sophia, the Divine wisdom

Egg tempera on canvas and wood, 33.5 x 27.5 cm
Recklinghausen, Ikonen-Museum

Numerous outstanding churches in the Byzantine and Russian empires dating from the early and middle Byzantine periods are dedicated to Sophia, the Wisdom of God. Among the most famous are the Hagia Sophia churches in Constantinople and Thessaloniki, St Sophia in Ohrid, and the Sophia cathedrals in Kiev in the Ukraine, and Novgorod and Polotsk in Russia. Sophia refers to the personification of the "Wisdom of God", as for example in Proverbs 9:1–6: "Wisdom hath builded her house, she hath hewn out her seven pillars …" In his first epistle to the Corinthians, Paul writes: "But of him are ye in Christ Jesus, who of God is made unto us wisdom, and righteousness, and sanctification, and redemption" (1:30). In contrast to the Old Testament, in other words, the Wisdom of God is understood in the epistle in unambiguously Christological terms. This was also true of Greek Byzantine Orthodox Christianity, while in the Russian Church a more Mariological interpretation later emerged under the influence of German mysticism.

It was not only in the theological literature that Sophia – the Wisdom of God was treated in very different and sometimes contradictory ways; the pictorial interpretation of the theme also varied. The 17th-century icon illustrated here follows the text of Psalm 44 (in the Western enumeration, Psalm 45), extracts from which are inscribed on the edge. Verses 2 and 3 are in decorative script at the top edge of the picture, verses 6 and 7 on the bottom edge, and verses 15 and 16 on the left-hand edge.

In the middle, Sophia is depicted as a crowned figure in imperial garments on a throne. The red of the flesh and the garment indicates enlightenment through the Wisdom of God; the crossed halo hints at the identity of Sophia and Christ. He is giving the blessing with his right hand, while in his left hand he is holding a scroll and a sword in accordance with verse 3 of the psalm ("Gird thy sword upon thy thigh…"). On either side, there stand, as in a deësis, the Virgin Mary to

the right (according to verse 9: "… upon thy right hand did stand the queen") and John the Baptist to the left, both of them winged and crowned. Behind the throne stand the archangels Michael and Gabriel in front of the Trees of Paradise. At the top edge of the picture, God the Father is giving a blessing from a piece of heaven surrounded by clouds, with a cherub to one side and a seraph to the other. Below, two angels are hovering. The one on the left is pouring out the "oil of gladness" (verse 7) on to the majestic fiery youth, while the one on the right is holding up a tower (temple) in both hands. Against an architectural backdrop, David can be seen to the left with a harp, and to the right Solomon with a dish and an open scroll, which quotes Proverbs 9:1: "Wisdom hath builded her house, she hath hewn out her seven pillars …" Below Solomon, we see the Virgin's parents, Joachim and Anne, while below David are the virginal companions of the king's daughter, who are being brought before the king (verse 14) – an allusion to the induction of the Virgin into the Temple. The warriors at the feet of Sophia have been cast down by the power of God (verse 5).

> **"my heart is inditing a good matter: I speak of the things which I have made touching the king: my tongue is the pen of a ready writer. Thou art fairer than the children of men."**
>
> Psalm 44 (45):2–3; inscription on the icon

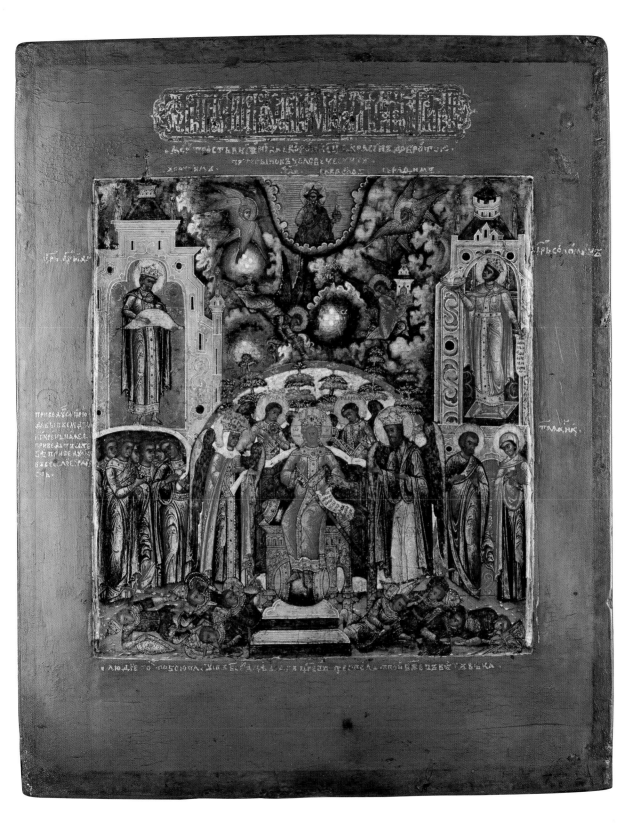

christ pantocrator

Egg tempera on wood, 119 x 84.5 cm
Recklinghausen, Ikonen-Museum

"I am the Way, the Truth, and the Life …" These words from St John's gospel (14:6) can be seen, in Greek, on the open book of gospels which the enthroned Christ is holding in His left hand. He is depicted as Pantocrator, in other words as Ruler of All, portrayed frontally, seated on a throne, majestic like a Byzantine emperor. The dark-blue tunic decorated with fine gold strips (assist) over a dark-red undergarment, together with the background, which is covered in gold leaf, are to be understood as signs of Christ's divinity: his glory and immateriality symbolize divine transcendence. Christ is depicted with a beard and long hair, parted in the middle. He has raised His right hand in blessing, the index and middle fingers together, the ring and little fingers touching the thumb. This gesture symbolizes the two natures of Christ, the divine and the human, which He unites within Himself, as well as the Trinity of Father, Son and Holy Spirit. His head is surrounded by a crossed halo, in which are inscribed the Greek letters οων – an abbreviation for the present participle of the Greek verb to be, i.e. the "one who is being", while beside His head can be seen the pairs of letters IC and XC, the abbreviations of Jesus and Christ respectively, which indicate the identity of the depicted redeemer with the divine person.

While the overwhelming majority of icons were created by anonymous masters, this one of the Pantocrator in majesty is signed and dated bottom right: "1653. By the hand of Elias Moskos". Elias Moskos originated from Rethymnon on Crete, and was one of the five most important Greek icon-painters of the 17th century. The battle for Crete between 1645 and 1669 and the final fall of the capital Candia (today's Herakleion) to the Turks forced many important painters into exile on the Ionian islands of Zakynthos, Corfu or Kefalonia. In 1646 Elias Moskos was one of those to settle on Zakynthos, where he lived and worked until his death on 26 January 1687. All his dated icons were painted either on Zakynthos or the neighbouring island of Kefalonia between 1649 and 1686. The one in Recklinghausen, dated 1653, is thus one of his early works. It is still in the tradition of Byzantine icon-painting, although most of his works were strongly influenced by Italian Mannerism.

This *Christ Pantocrator*, apart from the coloration, closely follows a somewhat smaller and narrower icon painted by the famous icon-painter Angelos in the second half of the 15th century, which was in the church of Hagios Spyridonos Flampouriaris on Zakynthos (destroyed in the earthquake of 1953) and is now in the local museum. Apart from the coloration, the added incrustations on the throne and a different text in the gospel book, Elias Moskos copied his 200-year-old model fairly exactly. Typical of Cretan icon-painting in both icons is the totally Byzantine style of the Christ figure with the throne in central perspective, strongly reminiscent of Italian architecture of the early Renaissance.

This large Pantocrator icon was doubtless painted for the Local Tier of an iconostasis, where it was affixed next to the Royal Door on the right.

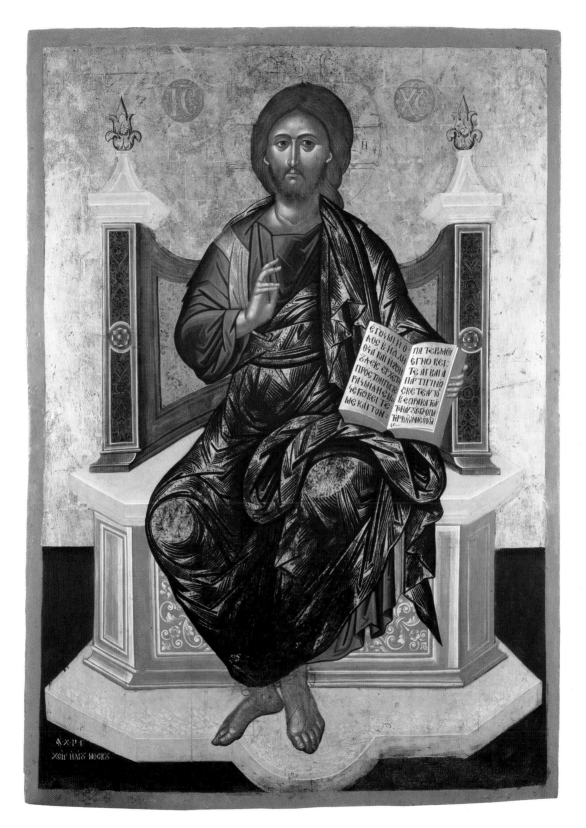

тhe нoly "Fools for christ" procopius and ıoann of ustyug

Egg tempera on oakwood, 30.2 x 24.7 cm
Recklinghausen, Ikonen-Museum

The "Fools for Christ" are found almost exclusively in the Eastern Church. Their form of asceticism can be traced back to as long ago as the 4th century, and was probably inspired by the words of Paul the Apostle in his first epistle to the Corinthians (4:10–13). The fools for Christ intentionally displayed a folly that makes them outsiders in society, bringing them contempt, persecution and in some cases physical abuse. They mostly had no fixed abode, and wore scanty clothing even in winter. Popularly, however, they enjoyed the reputation of particular sanctity, and were venerated as prophets and miracle-workers. Sometimes this veneration was tolerated by the Church or later even sanctioned.

The most famous Fool was Andreas of Constantinople (d. c. 946), whose biography was translated into Old Church Slavonic no later than the 13th century. Behind the mask of folly, and with symbolic speeches and mysterious actions, some fools in Christ entered into active opposition to the state authorities, publicly condemning the shortcomings and conventions of the official Church. Their heyday in Russia was during the 16th and 17th centuries. The veneration of the two Fools linked with Veliky Ustyug, Procopius and Ioann, was confirmed at the Council of Moscow in 1547, after previously being suppressed by the local clergy.

Procopius was said to have been a rich merchant from Lübeck who converted to Orthodoxy, gave away his money to the poor, and lived in Ustyug as a Fool for Christ. He is said to have slept on rubbish heaps in order to represent himself as "the trash of the world". In view of a miracle in the presence of the Mother of God of Ustyug, from whom oil flowed in answer to his prayer, and the defence he provided against a great hail of stones, he was venerated as a miracle-worker. Procopius is said to have died on 8 July 1303 at the gates of the Archangel monastery. In 1458 his grave began to be venerated, in spite of opposition from the clergy.

He became the role model for Ioann, a farmer's son from the vicinity of Veliky Ustyug, who made a home for himself in a hut next to the church of the Dormition of the Mother of God in the town. He lived on bread and water, and lay down on dungheaps or glowing coals. In his lifetime he is said to have healed the wife of Prince Feodor Krasny of Ustyug, and following his death on 29 May 1494 there ensued further miracles at his grave near the Church of the Dormition.

In honour of the two Ustyug "Fools", two rich merchants built stone churches in the second half of the 17th century: in 1656–1663 Nikifor Revyakin had a church built over Ioann's grave: it was dedicated to the Raising Aloft of the Cross; and in 1668 Afanasiy Fedorov Guselnikov built the church of St Procopius. It is from this period that this icon, one of the best works of the 17th-century Ustyug masters, probably dates. Procopius and Ioann turn in prayer and with devout expressions to Christ, who is depicted in a medallion giving them the blessing. In his hand Procopius is holding three pokers, which he carried point upwards when a fertile year was imminent, and point downwards when the harvest threatened to fail. The carefully painted, elongated figures with small heads, their garments covered in rich chrysography (gold highlighting), and the fineness of the draughtsmanship are typical features of the Ustyug school of this period. Beautiful trees are growing on the stylized mountains. The costliness and virtuosity of the painting, which flies in the face of the theme of the "Fools", who shocked their contemporaries with the neglect of their external appearance, shows the intense relationship with the Stroganov school.

"we are fools for christ's sake, but ye are wise in christ; we are weak, but ye are strong; ye are honourable, but we are despised."

I Corinthians 4:10

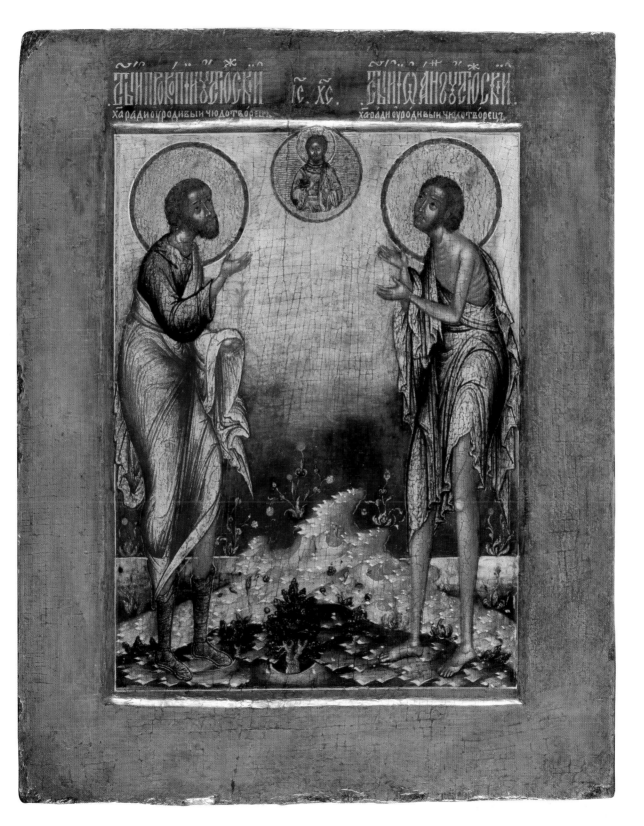

тне Last Judgement

Egg tempera on wood, 182 x 144.5 cm
Recklinghausen, Ikonen-Museum

This large icon shows the complicated and many-figured icono-graphy of the Last Judgement in five horizontal zones with an emphat-ic central axis. Above a band of clouds, we see the heavenly sphere, with the New Jerusalem on the left-hand side. Here, the elect are sit-ting at Christ's table. Next to them, God the Father is sending Christ to judge mankind. This uppermost zone is topped by a sky with sun, moon and stars, represented as a scroll being rolled up by two angels at the end of time. In the second zone down, Christ is enthroned as judge between the Virgin Mary and John the Baptist, the intercessors for mankind, and the twelve apostles as "jurors". At Christ's feet, Adam and Eve kneel as representatives of sinful humanity. Beneath Christ are the "Hetoimasia", in other words the throne prepared for His sec-ond coming, and the balance for weighing souls. Angels are using spears to repel the devils seeking to pull the scales down in their favour. Also in this row are the human beings to be judged. To Christ's right, i.e. His left as we look at it, stand the just, in other words various groups of saints. Among the sinners on His left, led by Moses, are men in oriental garb (embodying the unbelievers), scantily dressed women with luxuriant hair openly displayed, heretical bishops and un-just rulers.

The assignment of the sides to good and evil is continued in the bottom two rows. Below the group of the just we see Paradise with the Mother of God between the archangels as well as the Repentant Thief between Elijah and Enoch. Beside them is a circle containing the vision of the prophet Daniel, and opposite, on the right-hand side of the picture, the resurrection of the dead of the earth and the seas to the sound of trumpets. Further, the four worldly kingdoms according to the prophecy of Daniel are symbolized by fantastical beasts. At bottom centre, the blessed process behind Peter and other apostles towards the gates of Paradise, behind which Isaac, Abraham and Jacob are sitting with the souls of the just in their laps. Between Paradise and

Hell on the opposite side, depicted in bright red, a sinner is bound to a pillar. He led a life of sin, but also did good works, hence a decision on his fate has yet to be made. In the fire of Hell, the black figure of Hades is sitting on a two-headed lion, from whose maw the serpent of sin coils up as far as Adam's heel. On medallion-like growths along the serpent's body are depicted the sins for which the damned are being cast into the flames of Hell. Right at the bottom we see in graphic de-tail the punishments awaiting particular groups of sinners. Thus for example on the extreme right the "heretics and iconoclasts", in other words the opponents of icon-painting, for whom the painter of this icon would have had little love, are being tormented by the "never-rest-ing worm". The stripe-like composition is held together by an up-and-down movement on the sides. To the left monks with angelic wings are ascending to the Heavenly Jerusalem, while on the right, the rebellious angels are being cast into Hell.

Numerous Old Church Slavonic texts on the edges of the icon and in the picture itself explain the very lively and colourfully painted scenes at the Last Judgement.

> "тhe earliest still extant Judgement Day picture in вyzantine art is in the frescoes of st stephen's church in кastoria (pre-1040)."
>
> **Beat Brenk, 1966**

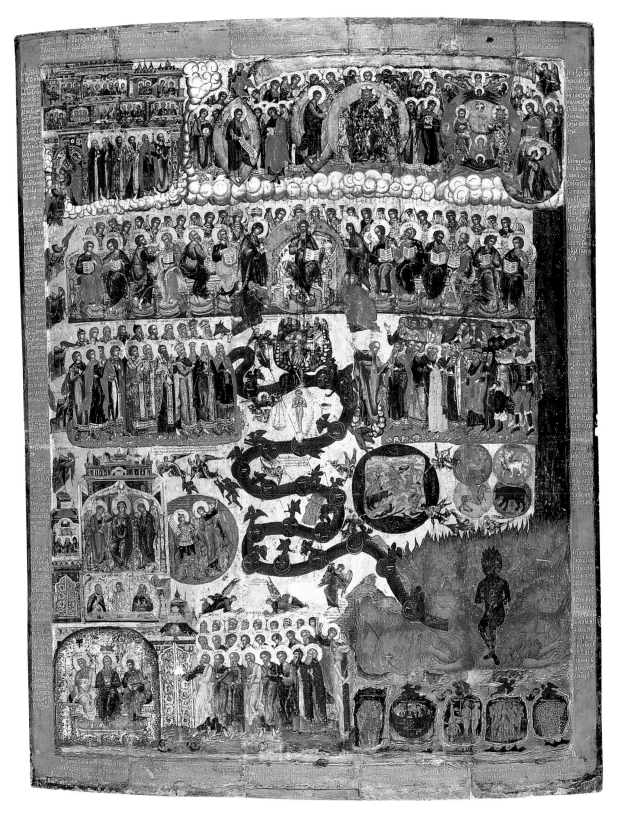

st Luke the Apostle and Evangelist

Egg tempera on spruce, 55 x 43.2 cm
Recklinghausen, Ikonen-Museum

Sitting on a broad stool in front of a table that is not much higher, St Luke the Evangelist is using a quill pen to write the introduction to his gospel in Old Church Slavonic on a pad of white paper: "Forasmuch as many have taken in hand …" In front of him, on the table, stand an inkwell, the blades needed to sharpen the quill, a case for the writing implements and a candlestick with a burning candle. A blank papyrus scroll is draped over the table. Painted no less lovingly than these items is a bluish-green cupboard behind the writer, its door open, allowing us to see a golden jug and a beaker on the top shelf, and a white towel hanging over a rod.

Luke is sitting amidst extravagantly ornamental architecture. Behind him is a pink porch with a pyramidal roof over a column, which forms the left-hand edge of the icon. On the right is a dark building with pink-framed windows and a gateway, through which can be seen a further doorway closed off by a metal grid. A decorated bluish-green column rises on the right-hand edge of the picture, while the ensemble is completed by an ochre façade in the background. Small balustrades, turrets and cupolas provide architectural ornamentation, although it is often difficult to know what belongs where. Doubtless many details have been borrowed from Western engravings, but the perspective was irrelevant for the icon-painter. This is clear too from the rosé-coloured floor tiles, which are depicted in the reverse perspective usual in icons.

At the top centre, in a garland of clouds, can be seen the evangelist's symbol, namely a winged bull holding a book.

This icon of the evangelist at work, which was once in the Royal Door of an iconostasis, is painted in a style characteristic of the painting of the late 17th century in the city of Yaroslavl, which is located on the Volga to the north of Moscow. This style is distinguished by exuberant architectural depiction, meticulous ornamentation, and miniature-like details. It reflects the opulence of the city, which in the 17th century experienced an economic and cultural heyday as one of Russia's most important trading centres. By the end of the century it was the second-biggest city in the Russian empire. After the destruction of much of the city by fire in 1658, the merchants and craftsmen had countless stone churches built to replace the old wooden churches, and commissioned frescoes for them. Icon-painting too witnessed a major boom. The Yaroslavl icon-painters took their bearings not so much from the contemporary innovations of Simon Usakov in the capital, with his striving for three-dimensionality, but interested themselves more in a refinement of painting technique, in linearity, and in original coloration, such as was typical of the works of the Stroganov school. Rich decoration of apparel and architecture, genre-like scenes or depictions of historical events, a large number of small marginal pictures in the case of biographical icons – these are the typical features of the Yaroslavl icons of the late 17th century.

The Recklinghausen icon of St Luke has close affinities to the depiction of the evangelist from the Royal Door of the Church of the Prophet Elijah in Yaroslavl, which was painted in about 1650. It has even more detail than this one, but the details are not so small, as is also the case with the icons of the Yaroslavl painter Semyon Spiridonov Kholmogorets (1642–1695) dating from the 1680s. For this reason, we can say that it probably dates from after the middle of the 17th century, while predating the works of Semyon Spiridonov.

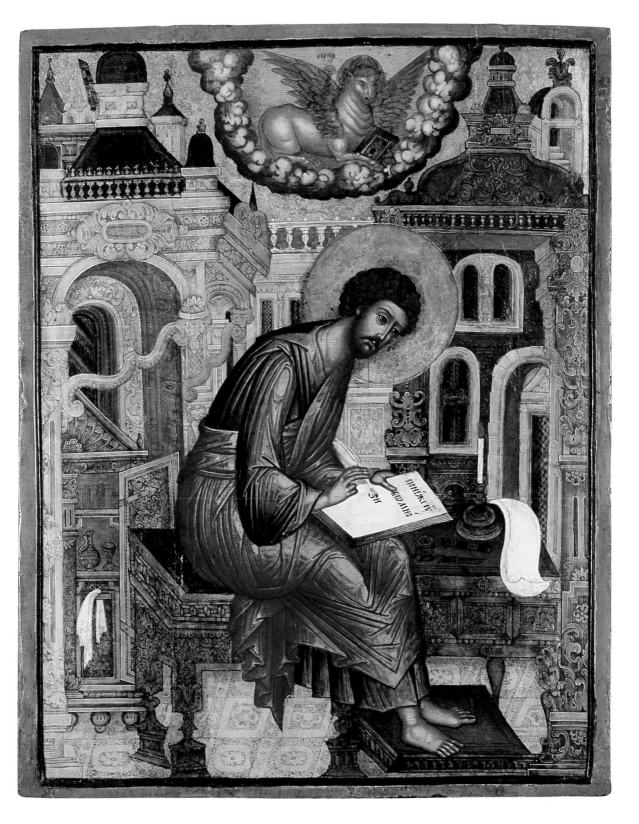

ΛΟΥΚΑ

тhe нoly тrinity

Egg tempera on wood, 110.5 x 69.5 cm
Recklinghausen, Ikonen-Museum

The most important New Testament source for the Trinity is the charge of the risen Christ to His disciples: "Go ye therefore, and teach all nations, baptizing them in the name of the Father, and of the Son, and of the Holy Ghost …" (Matthew 28:19) along with the reports of Christ's baptism (Matthew 3:16–17; Mark 1:10–11; Luke 3:21–22). When depicting the Baptism and other events in Christ's earthly life with a reference to the Trinity, such as the Annunciation, Nativity and Crucifixion, artists could depict each of the three Persons in their own guise (the Holy Spirit as dove, the Father through the symbol of the hand along with the segment of Heaven). Things were different when it came to conveying the timeless existence of the three divine Persons as three-in-one with no reference to a particular scene.

At an early stage, what came to the fore as a valid image of the Trinity in the Eastern Church was a symbolic representation that was known as the philoxenia (hospitality) of Abraham, as it was based on the visit, described in Genesis 18, of three men or angels to Abraham and Sarah. Abraham had a calf slaughtered and entertained the guests, who then promised him that his aging wife Sarah would give birth to their longed-for son. This Old Testament story had already been interpreted by the Fathers of the Church as the first revelation of the three Persons of the Trinity.

The first representations in art, such as the mosaic in the church of San Vitale in Ravenna (546/547; ill. right), show the three men as being of equal status, while later in some cases the central angel is identified as the second Person of the Trinity by the crossed halo, an attribute of Christ alone, and the abbreviations of His name IC XC. The definitive symbol of the Trinity was created in about 1411 by the famous icon-painter Andrey Rublev (p. 2), who dispensed with all narrative elements such as Abraham and Sarah, the richly decked table and the slaughter of the calf, and for his icon, which was destined for the iconostasis of the main church of the Sergei-Trinity monastery,

concentrated wholly on the three angels sitting around a table with a chalice. He enclosed the figures, who face each other lovingly, in a circle.

Although the Moscow Stoglav Council ("hundred chapter council") of 1551 prohibited the differentiation of the individual hypostases and recommended future artists to employ Rublev's Trinity icon as their binding pattern, the narrative elements predominate once more in the 16th century and above all in the 17th. This is clear in this large icon too, which was probably the patron icon in a church dedicated to the Trinity. Here the three angels are sitting at a richly decked table, on which three chalices, knives, a jug, small loaves and other objects can be seen. Abraham's tent or house is replaced by a richly detailed, colourful town, while on the right loom the three peaks of a mountain on which grow stylized trees. The oak in the centre of the picture designates the location of the event, the plains of Mamre. Abraham and

Philoxenia of Abraham (detail), 546/547

Sarah appear behind the angels with filled dishes in their hands, in order to serve their guests. The pleasure taken by the artist in decoration is also apparent in the thrones on which the angels are sitting, in the table, and in the broad suppedaneum or footstool, supported on little arches. All of these are decorated with silver leaf.

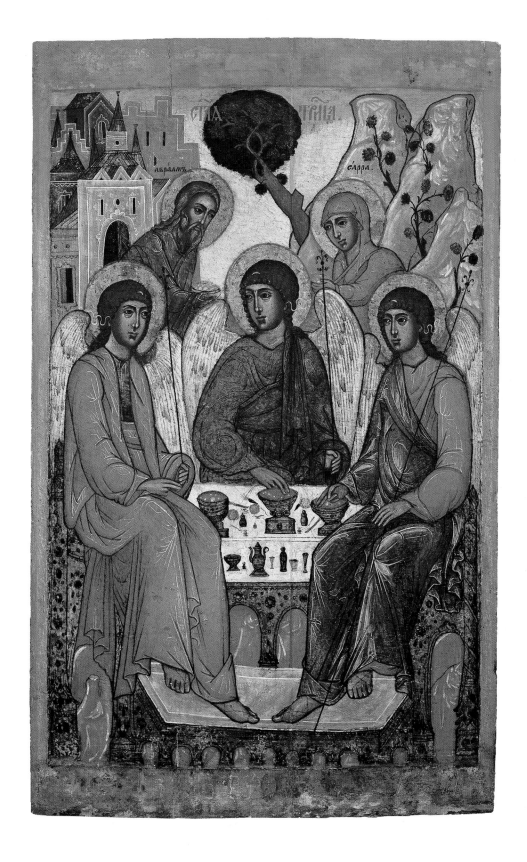

СТ҃А ... ТРЦА

АВРААМЪ

С́АРРА

"In thee … the whole of creation rejoices"

Egg tempera on wood, 174.5 x 156.5 cm
Recklinghausen, Ikonen-Museum

Alongside icons representing Christ, the Virgin, angels, saints and Church feasts, there are also others with more complex motifs, for example hymns in pictorial form. This is the case with a large icon based on a text in honour of the Mother of God. This text is reproduced in Old Church Slavonic in a cartouche at the bottom edge of the picture.

"In thee, blessed one, the whole of creation rejoices,
the choir of angels, and the race of men!
Consecrated temple and paradise of the Word,
virgin glory from which God became flesh
and took on the form of a child, He, our God who was before
all the ages, made thy womb a throne wider than the heavens.
In thee, blessed one, the whole of creation rejoices,
Honour be to thee!"

The centre of the icon is formed by a large luminous aureole with the "platytera", the name given to the Mother of God in Majesty, holding Christ Emmanuel frontally before her. This description refers to the line in the hymn "wider than the heavens" (in Greek, *he platytera ton ouranon*). In a semicircle, "angels of the Lord" surround this central roundel. They are standing in front of a church with five domes, strongly reminiscent, by virtue of the round pediments in the form of shell niches above the architrave, of the Archangel cathedral in the Kremlin in Moscow, which was built by the Venetian architect Alovisio Novo in 1505–1508. The cathedral is flanked on either side by two pink buildings with classical arches and columns, above which we see hills with trees in blossom. The large inscription on either side of the domes explains the significance of this architectural and natural backdrop, which takes up another aspect of the hymn: "Consecrated temple and paradise of the Word."

On the icon much space is devoted to praise issuing from "the race of men". In three rows, various groups of saints are facing the Mother of God on her throne: kings and princes, holy fathers, nuns and monks and martyrs. They are led by the two famous hymn-writers John of Damascus (c. 675–749), regarded as the author of the 9th ode of the canon, and Cosmas of Mayuma (706–760).

Below, the apostles Peter and Paul flank the cartouche with the text of the hymn. Following them from the left are hierarchs and further apostles, and from the right kings David and Solomon and warrior saints in magnificent armour. The central axis is emphasized by the frontal figure of John the Baptist as winged "angel of the desert" beneath the throne of the Mother of God.

This icon is a striking example of the Western, Baroque tendency in Russian icon-painting in the late 17th century. A monumental work, it was presumably painted in the imperial workshops in the Kremlin armoury. This view is supported on the one hand by the delicate coloration in which red, pink, orange and green tones predominate along with gold, and on the other by the depiction of the Archangel cathedral, which served as the burial place of tsars and princes. Another clue to the origin of the icon in this courtly milieu might be seen in the fact that saints of princely blood are over-represented among the "race of men" offering praise to the Mother of God.

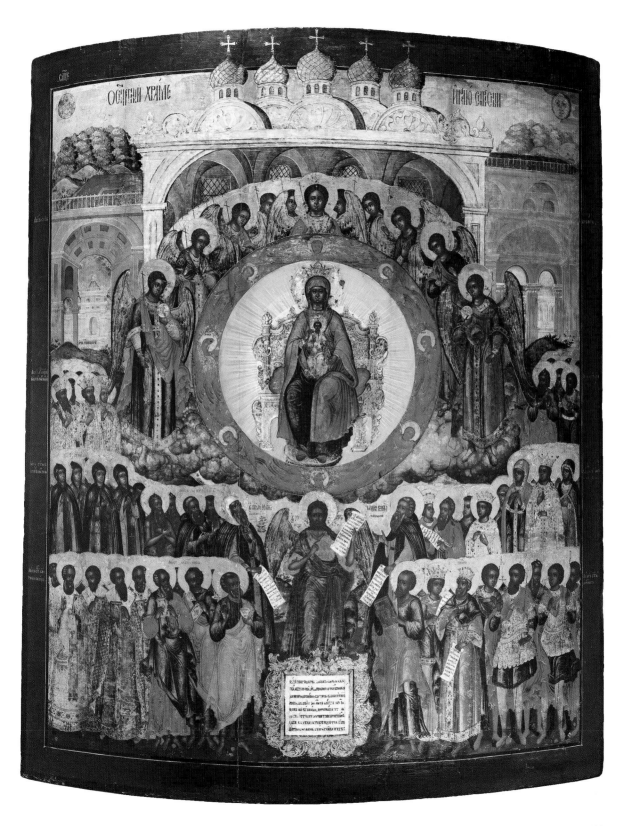

ss. stephen and christopher

Egg tempera on oak, 20.6 x 15.8 cm
Recklinghausen, Ikonen-Museum

In the collection of the Ikonen-Museum Recklinghausen there are some icons showing a strange-looking saint. His name is known to us from Western depictions, and as the patron saint of motorists. But unlike these Western depictions, which show St Christopher as a giant carrying the young Jesus across a river on his shoulders, most icons show him with an animal's head. Although his nickname *kynokephalos* means dog-headed, there are numerous variations ranging from a horse's or pig's head to one which, while human, is deformed. The idea of a dog-headed saint was probably not so unusual for the medieval mind. Hybrid creatures, part man, part beast, occur in classical mythology quite frequently: we only have to think of centaurs, sirens and satyrs. From Egypt we know the jackal-headed god Anubis, and in the Middle Ages we find, for example on the Romanesque tympanon of the portal of Sainte-Madeleine in Vézelay in Burgundy (c. 1130), among the depictions of the various peoples to whom the apostles are preaching the gospel, one tribe with animal heads. In the mass in honour of St Christopher in the *Liber Mozarabicus Sacramentorum*, dating from the 6th century, the saint's dog-headedness is mentioned. The earliest pictorial representation can be found on terracotta icons dating from the 5th and 6th centuries excavated between 1985 and 1988 not far from Vinica near Skopje in Macedonia. They show full-length frontal images of saints Christopher and George, the former turning his dog's head towards the latter.

According to legend, the future saint came from a race of dog-headed cannibals and was originally called Reprobus (Lat.: the cursed). His conversion to Christianity and his baptism brought him not only a new name, Christophoros (Greek: the Christ-bearer), but also a human figure and the ability to speak. From Samos in Lycia he travelled the country as a missionary, preaching the gospel. He succeeded in convincing many of the Christian message, as God reinforced his preaching with miracles, for example the flowering of his staff.

During the persecution of Christians under King Dagnus, Christopher suffered many tortures, which however he came through unharmed. Two prostitutes, sent to seduce him in prison, were converted, along with the guard. The attempt to burn him cost a number of people their lives, when 30 houses were destroyed by the flames. His life was only ended when his head was cut off.

On this icon, painted in Greece at the start of the 18th century, Christopher is shown in soldier's dress with a long spear in his right hand. In his left hand, he is holding a shield.

Depicted frontally, the saint is flanked on the left by St Stephen, the first martyr, one of the seven deacons consecrated by Christ's apostles through the laying-on of hands. He is, as is usual, shown as a youthful deacon with the tonsure, and is holding a thurible in his right hand. The object in his left hand possibly represents the stones as attribute of his martyrdom − or could it be a model of the city of Rome, whose patron he is, together with St Lawrence?

The Acts of the Apostles (chapters 6 and 7) reports how Stephen was slandered before the Council, and was accused of blasphemy. The judges saw his face lit up like that of an angel, but "stopped their ears" as he addressed them fierily in his defence, driving him from the city, and stoning him to death. After the discovery of his relics, Stephen was buried together with St Lawrence, likewise venerated as an early deacon and martyr, in San Lorenzo fuori le mura in Rome. While the two deacons are often depicted together, the combination of Stephen and Christopher is very unusual.

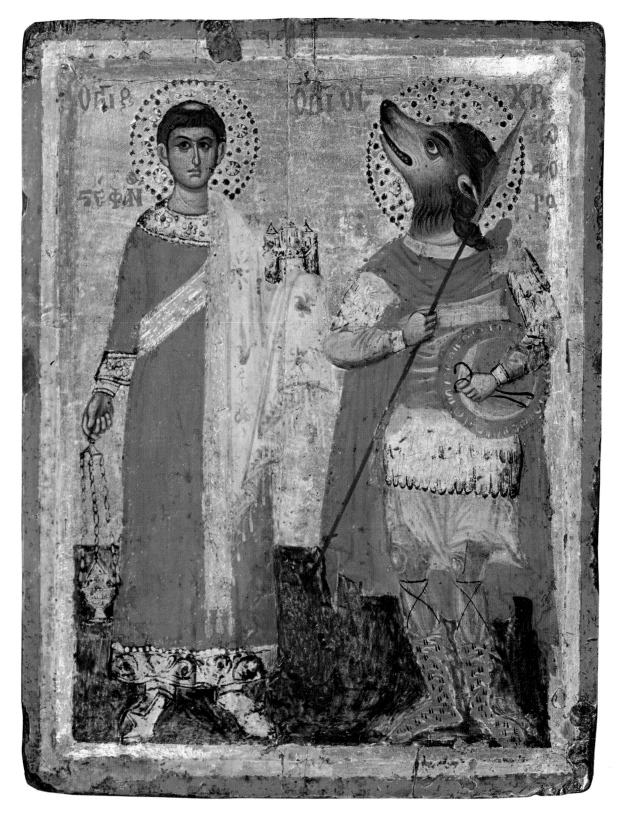

The Baptism of the Eunuch of the Ethiopian Queen by Philip

Egg tempera on wood, with gilt frame, 39 x 36 cm
Recklinghausen, Ikonen-Museum

This icon, distinguished by the quality of its painting and wealth of detail, is striking not least on account of its oval shape and its gilt Rococo frame. But it is the theme that is really unusual, perhaps indeed unique. On the left is a baptismal scene, and on the right a chariot drawn by two horses, and carrying two men in conversation, one of whom has an open book in his lap. Only the golden inscription in Old Church Slavonic top left reveals that it records the event reported in chapter 8, verses 26–39 of the Acts of the Apostles. The saint with the golden halo is Philip, one of the seven deacons of the Jerusalem congregation. In the Byzantine Church he was included among the 70 apostles, but often confused with his namesake, one of the Twelve.

Acts reports that on the almost deserted road from Jerusalem to Gaza, Philip met a high-ranking eunuch of the Ethiopian queen, who "had charge of all her treasure". He had been to Jerusalem to pray to the God of Israel, and was now on his way home in a chariot. He was reading aloud the passage in the book of the prophet Isaiah, where it says that "He was led as a sheep to the slaughter; and like a lamb dumb before his shearer, so opened he not his mouth." Philip offered to explain the incomprehensible scripture, and preached the gospel of Jesus. When they came to "a certain water", the Ethiopian requested to be baptized. They entered the water, and Philip baptized him.

The two scenes are located in a mountainous landscape with two stylized trees. The chariot is depicted in a perspective unusual for icon-painting. It is shown foreshortened, and somewhat from above, exactly as in an engraving in the Piscator Bible printed in Holland in 1650 and 1674, which served the painter as a model. The apostle as baptist is also shown in a posture similar to that on the engraving, while the Ethiopian deviates from the model in being naked and standing upright.

The same engraving from the Piscator Bible had already been used as a model for a fresco dating from 1680/81 on the West wall of the church of the prophet Elisha in Yaroslavl, albeit for a different scene. In Yaroslavl there is only one person in the chariot, namely the Syrian general Naaman, who was cured of leprosy by the prophet Elisha (II Kings 5). The frescoes in this church were created by artists from Kostroma under the direction of Guri Nikitin and Sila Savin, who, three years later, illustrated the Acts of the Apostles on the West wall of Holy Trinity church in the Hypathios monastery in their home city. Here we also find the baptism scene depicted on our icon. One might have expected the painter to have used the same engraving as a pattern, but the fresco shows the chariot and the horses in a far more traditional way, from the side, albeit with a frontal view of the two people in it, and of its roof.

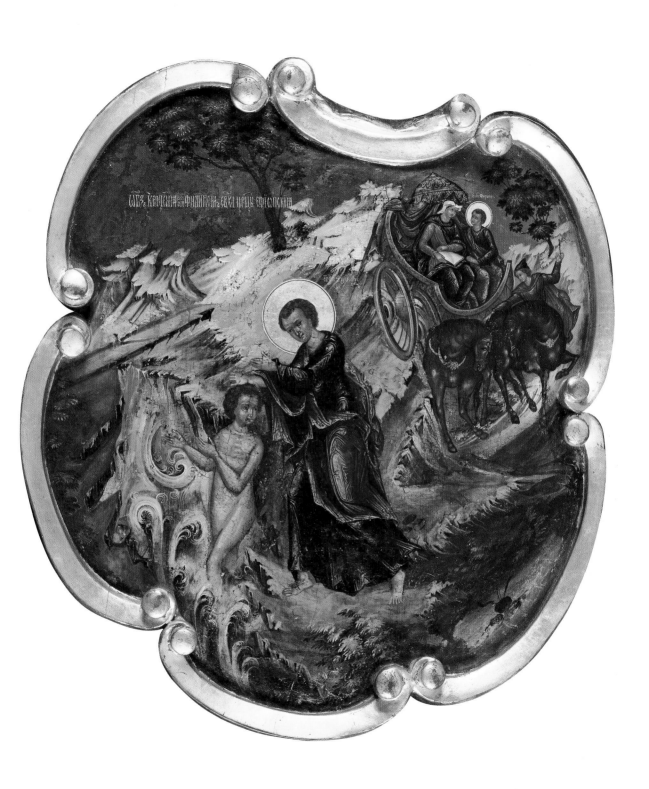

тhe creed

Egg tempera on wood, 40 x 33.5 cm
Recklinghausen, Ikonen-Museum

In numerous strips and many individual scenes, we have here a very infrequent and complex motif, namely the Orthodox Creed. It was formulated at the First Ecumenical Council in Nicaea in 325 and extended at the Fourth Ecumenical Council in Chalcedon in 451. It was introduced officially into the liturgy by Emperor Justin II (d. 578). The Old Church Slavonic text of the Creed is inscribed in golden letters around the edge of the icon, thus encompassing the content of the individual depictions.

The upper portion of the icon deals mainly with the first two Persons of the Trinity: on the left, God the Father is depicted as the "Ancient of Days" in accordance with the vision of Daniel (Daniel 7:9); in the middle, in accordance with the type known as "fatherhood" he is presenting the Son on His lap; while on the right we see Christ enthroned as Pantocrator.

In the next row, to the left and right, we see God as Creator of Heaven and Earth; above the creation of the beasts and of Adam and Eve (left) and their expulsion from Paradise (right) we see the sky and the stars. Between these two scenes, the Council of Nicaea of 325 is depicted, at which the Alexandrine priest Arius questioned Christian teaching, and where the foundations of the Christian Creed were formulated.

The next two rows depict the stations of Christ's earthly life and his Passion: the Annunciation, the Nativity, the Trial before Pilate, the Scourging, the Crucifixion, the Deposition and the Entombment. The fourth row illustrates the Resurrection (Descent into Hell) and Ascension, along with the Second Coming and the Last Judgement.

The following articles of the Creed, which deal with the Holy Spirit and the Trinity, are depicted in three medallions on the central axis of the picture in the lower half of the icon. Father and Son are enthroned in juxtaposition, surrounded by angels. In the lowest medallion angels are holding aloft the gloriole with Christ Pantocrator seated in majesty.

The second row from the bottom deals with one holy, catholic and apostolic Church. On the left the saints have assembled, among them the apostles, the children who were the victims of the Massacre of the Innocents, as well as prophets and patriarchs. On the altar, Christ is standing both as high priest and sacrifice, flanked by the Virgin Mary and John the Baptist along with angels. To the right, the creators of the liturgy, Basil the Great and St John Chrysostom are handing their texts to the host of saints. On the right-hand side, Christ as high priest is celebrating the heavenly liturgy at an altar which is being approached from both sides by the apostles in the company of John the Baptist.

The bottom row deals with baptism, resurrection and the life everlasting. On the left, Peter is preaching to a group of people, who subsequently receive baptism in a lake. In the middle we see the resurrection of the dead from the earth and the sea, and finally, on the far right, we see Paradise, where Abraham, Isaac and Jacob are holding the redeemed in their laps.

The icon is probably the work of masters from Palekh near Vladimir, who were famous for icons in fine, miniature-like painting. The balanced coloration also speaks in favour of this artists' village as the place where this icon was created, probably in about 1800.

"As in palekh in other places too rich merchants ... supported the making of icons ... in his story *The sealed Angel* Nikolai Leskov gives us a splendidly lively description of the milieu in which old Faith icon-painters worked."

Konrad Onasch, 1995

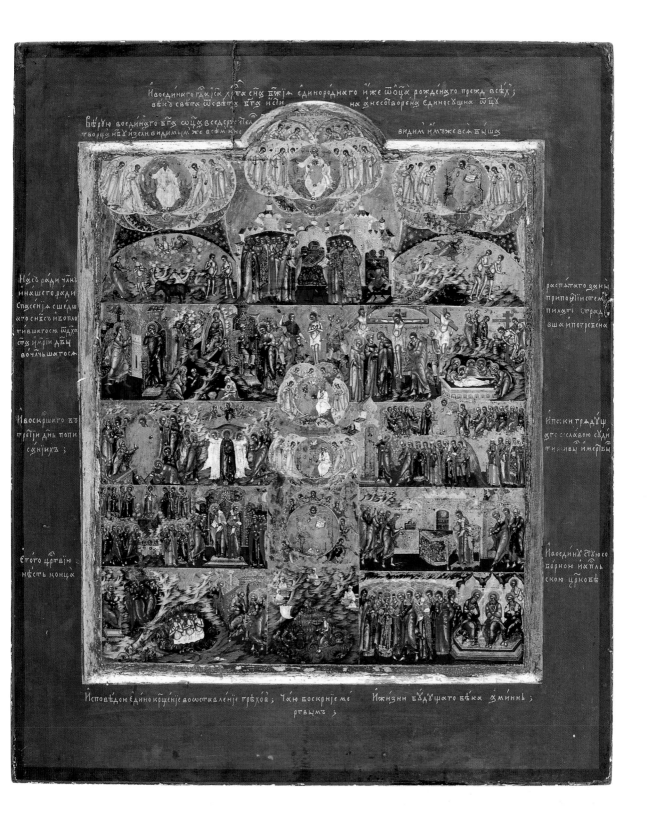

Depiction of an Iconostasis

Egg tempera on wood, 72 x 60 cm
Recklinghausen, Ikonen-Museum

In 19th century Russian icon-painting we find icons depicting a complete church iconostasis, mostly with five tiers of icons, sometimes seven. The extraordinarily delicately painted icon in Recklinghausen is unique in depicting no less than ten tiers with a total of 134 individual icons. Between the usual tiers (Local, Feasts, Deësis, Prophets and Patriarchs) further tiers of small icons are interpolated. Above the Deësis, consisting of the Twelve Apostles, scenes showing the martyrdoms of the corresponding apostles are inserted, and above the Prophets scenes of their activities. Above the Patriarchs is a tier with pictures from Genesis, and above this, events relating to the Passion of Christ, with the Crucifixion in the middle as the culmination of the icon.

The icon is constructed on a strictly symmetrical plan, the central axis emphasized by broader compositions with more figures. These extend mostly across two related rows. Beneath the Crucifixion, the representation of the Trinity (based on the so-called "fatherhood" type) takes up the middle of the Patriarch Tier with the Genesis scenes above. Then follows the anthem "There is joy over Thee" between the prophets and the tier with depictions of their deeds. The Trinity in the New Testament form is at the centre of the Deësis Tier with the martyrdoms of the apostles, and the Last Supper is above the Royal Door in the Feasts Tier. The Royal Door in its turn has the usual depictions of the Annunciation and the four Evangelists.

The figures on the Deësis, Prophet and Patriarch Tiers are all facing these central pictorial fields. They are full-figure depictions, and are holding scrolls with texts in their hands, still legible in spite of the tiny writing.

Further large pictorial fields are to be found in the Local Tier. The side doors show the deacons Stephen (left) and Lawrence (right), the stoning of the former and the beheading of the latter being shown in the base zone. To the left of Stephen is an icon on which is repro-

duced the anthem "It is worthy to praise Thee", and to the right of this the "Mother of God, joy of all sufferers". As usual, the icon of the Mother of God is placed to the left next to the Royal Door. She is depicted here full-length, as is Christ with saints lying at His feet on the right-hand side. Between the Christ icon and the South Door with St Lawrence is an icon with the Pokrov depiction, and on the far right the psalm "Praise ye the Lord" is painted in particular detail.

The painter of this icon did not seek to depict a particular iconostasis, but rather an ideal picture of the Church. And above all he wanted to prove his great skill to his cultured client. The icon is eye-catching on account of its miniaturist technique, many-figured scenes often being depicted on the smallest of areas, its balanced and noble coloration, and its comprehensive and well-considered iconographic programme. There is much to suggest that it was painted in the artists' village of Palekh, which was famous for its miniature painting: the typically ivory-coloured background, the carefully worked garments, the detailed architectural accessories, the depiction of the Pokrov icon in the Local Tier. The icon is the highest-quality example of a relatively seldom-depicted motif, and an unusual major work of late icon-painting.

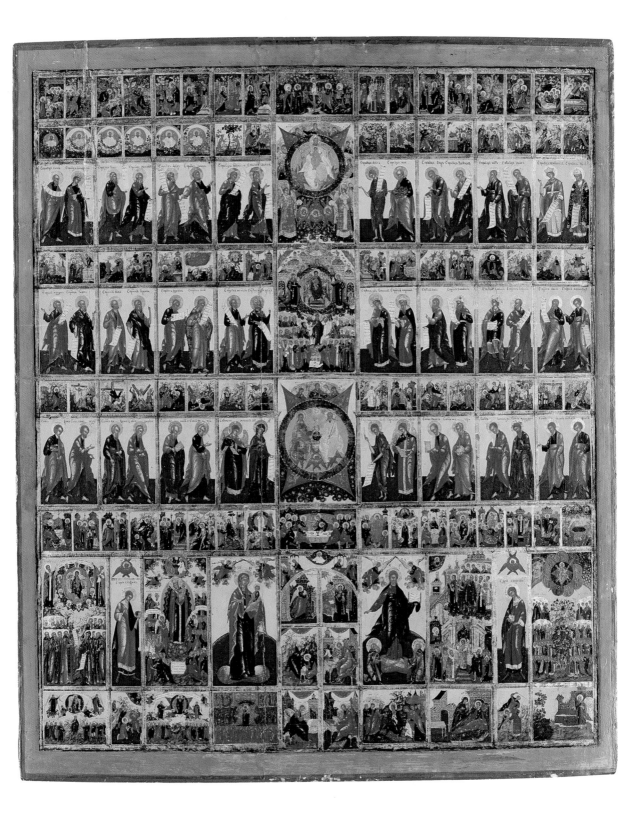

тне ғeasts of the church year

Egg tempera on wood, 31.7 x 26.3 cm
Recklinghausen, Ikonen-Museum

Feasts play an important role in the Church calendar. Every day of the year is dedicated to one or more saints or to a feast of the Lord or the Virgin. The feasts of the Church calendar raise awareness of the salvation story and its progress time and again. This is the result, however, not only of the liturgical and gospel texts read at the celebration of the feast, but also of pictorial representations of the feasts. These are present not only in the programme of the church ornamentation with its frescoes and mosaics, but also on the icons in the Feast-day Tier of the iconostasis.

In addition there are individual icons with feast-day scenes, which are placed on a lectern in the church on the relevant day to be venerated by clergy and congregation.

From the 10th century, a more or less fixed cycle of feast-day pictures emerged, known as the Dodecaorton (Gk: *dodeka heorton* = twelve feasts) and comprising the most important feasts of the Lord and the Virgin in the Church year.

While the sequence of Church feasts in the books intended for readings at services is determined is geared to the dates of the feasts in the course of the Church year, the feast pictures on icons are mostly arranged according to the chronological sequence of the events they depict.

This is also true of what are known as feast-day icons, which were extremely popular in Russia in particular in the 18th and 19th centuries. They almost always centre on the Easter festival, the culmination of the liturgical calendar. Following the compositional principle of a biographical icon, it will be framed by 12, 14, 18 or more smaller marginal fields with the remaining feasts. In the 19th century, a second, inner "wreath" with Passion scenes was sometimes added. Comprehensive icons like these allowed the devout to bring together all the major depictions of the Church year in a small space in their homes.

The icon depicted here, which was painted in high-quality miniaturist technique in about 1800, depictions of the Harrowing of Hell and the Resurrection of Christ are surrounded by 16 other, smaller feast-day scenes. The top row depicts the Nativity of the Virgin (8 September), the Entry of the Mother of God into the Temple (21 November), the Holy Trinity in its Old Testament type (Whit Sunday), the Annunciation (25 March), the Nativity of Christ (25 December); in the next row we see the Presentation of Jesus at the Temple (2 February) and the Baptism of Christ in the Jordan (6 January); in the third row, the Entry of Christ into Jerusalem, the Transfiguration on Mount Tabor (6 August); and below that the Ascension, and the Dormition of the Mother of God (15 August). In the bottom row, finally, we see the Raising of Lazarus, the Beheading of John the Baptist (29 August), the Fiery Ascension of the Prophet Elijah (20 July), the Exaltation of the Cross (14 September) and the Protection of the Mother of God (in Russian, *Pokrov*: 1 October).

The names of the feasts are inscribed in gold letters on the olive-green margin of the icon. Gold also plays a major role as the background colour and in the meticulously painted ornamentation and highlighting on the garments, giving the icon a solemn charisma. Each individual scene is executed in great detail, and is played out either against a fantastical architectural backcloth or in the countryside. The icon was probably painted in the famous artists' village of Palekh, which is famous for its exquisite miniaturist work.

great patriarch crucifix

Bronze with enamel in five colours, 37.5 x 23.5 cm
Recklinghausen, Ikonen-Museum

Alongside icons painted on wood, crosses and icons on copper, bronze or brass were popular in Russia, particularly from the 17th century. They were cast in various shapes and sizes, using expendable-mould techniques. They range in size from small pendants to rectangular panels and even triptychs and tetraptychs, in other words three or four-part folding icons, which were especially popular. After casting, the finishing touches were applied, and then the pieces were gilded and in some cases ornamented with coloured enamel.

The most important centre for the manufacture of metal icons was, from 1719, the monastery of the Old Believers on the Vyg river in northern Russia. While two decrees of Peter the Great in 1722 and 1723 banned the trade in the "inartistic" and "undignified" crosses and metal icons, the ban could not be enforced. Even less observed was a new ban in 1843, which was accompanied by the threat of confiscation. When in 1854 the large workshops on the Vyg were closed together with the monastery, production was transferred to small family businesses in the villages of northern Russia, and also to larger foundries belonging to the Old Believers in Moscow and the Kostroma region.

Metal icons decorated the "best corner" of the Russian house, they were taken on journeys, and they have been found on the bodies of fallen soldiers. In the 19th century they were attached to wooden grave-crosses.

The many different shapes of cross culminated in a comprehensive composition, whose luxurious finish and rich decoration gave it the name, among the Old Believers, of great patriarch crucifix, or, less respectfully on account of its shape, spade. The centre of the plate is occupied by the crucified Christ on the eight-ended cross with three cross-bars. It is extended by two vertical rectangular panels with the four witnesses of the Crucifixion (Martha and the Virgin Mary on the left, and St John the Evangelist and the centurion Longinus on the right) and is framed by 14 almost square pictorial fields. With one ex-

ception, these depict feast-day scenes taken from the widely known tetraptychs. The sequence follows the Church calendar, and should be read clockwise, starting bottom left: the Nativity of the Mother of God, the Entry of the Mother of God into the Temple, St Nicholas (6 December), the Nativity of Christ, the Baptism of Christ, and above these, the Presentation of Christ in the Temple and the Annunciation. On the right-hand side, we have, from top to bottom, the Entry into Jerusalem, the Harrowing of Hell, the Ascension, the Holy Trinity, and below these the Descent of the Holy Spirit, the Transfiguration on Mount Tabor, and finally the Dormition of the Mother of God.

The two onion-shaped fields at the top show the Holy Trinity in New Testament form (left) and the Feast of the Exaltation of the Cross (right). Between them, Our Lady of the Miracle of Novgorod, in a circle, and above this, a further picture of the Mother of God, surrounded by four medallions arranged in the shape of a cross. At the very top of the cross are 15 seraphim, seated on long staves and arranged in an arch. This decoration was only customary in the foundry of the Priestly Old Believers in Guslitsa not far from Moscow.

Great Patriarch Crucifix, 19th century

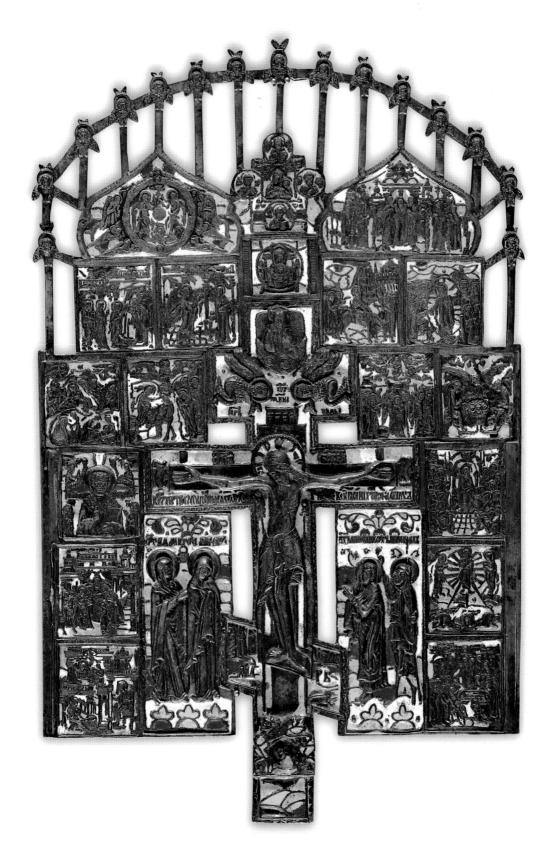

The Fiery Ascension of the Prophet Elijah

Reverse-glass painting, wooden frame, 52.3 x 41.3 cm
Recklinghausen, Ikonen-Museum

The reverse-glass painting of icons became a popular secondary source of income for Orthodox Transylvanian peasants from the first half of the 18th century, especially in winter. Mostly the whole family divided up the different work processes between them. Alongside these lay painters, the 19th century saw the appearance of professional reverse-glass icon-painters, some of whose names we know.

Most reverse-glass icons come from the area between Sibiu and Brasov in Romania, in particular Marginimea Sibiului and Scheii, a suburb of Brasov. But they were also traded, both at fairs and door-to-door, in the other provinces inhabited by Orthodox Romanians (Moldavia, Walachia).

Reverse-glass painting involves first of all the outline drawing, and then the application of paint, to a sheet of glass. The complete picture is then turned over, giving a mirror-image. The glass thus fulfils two functions: it is both the picture-support, and a protective coating. The wooden frames, consisting of four pieces joined together, are mostly painted or grained, and sometimes profiled. The range of motifs is narrower than what we find in icons painted on wood, although it was also enriched by a few subjects taken from the neighbouring Catholic regions, such as the Coronation of the Virgin or Christ as the vine. The most popular motifs were the patron saints of work in the fields, in particular the prophet Elijah, who was believed to protect the farm from lightning and conflagration, and send rain in times of drought. Almost always it is his Fiery Ascension that is depicted: this proved his domination of the element of fire.

In the centre of the icon two red, winged horses are seen drawing Elijah's golden chariot over a bank of clouds up to Heaven. An angel hovering in the top left-hand corner is holding the reins of the horses and flourishing a whip in his right hand. In the middle, Christ is blessing the prophet, while on the right, the Eye of God is watching. In his left hand Elijah is demonstratively flourishing the sword with which he slaughtered the priests of Baal. Beneath the bank of clouds, in the earthly sphere, we see two depictions of Elijah's pupil Elisha. Over a long white undergarment he is wearing a jacket based on the costume of Romanian peasants. On the right, he is seen taking up Elijah's mantle, symbolizing the transfer of the latter's prophetic powers. On the left, he is looking with raised arms at the vanishing prophet.

The icon is dated 1878 on a golden plate. Above Elijah, we can read on a scroll the title of the icon in Romanian (but in Cyrillic script) "The holy prophet Elijah". Large red flowers cover all the blank areas of the background. This *horror vacui* is a widespread stylistic feature of reverse-glass icons, alongside very bright colours, two-dimensionality and the labour-saving dispensation with details.

An iconographically very similar icon from the Nentwig collection, dated 1876, and attributed to the painter Savu Moga, suggests that the icon illustrated here could well have been painted in the circle of this, the most important painter in Transylvania.

"And it came to pass, as they still went on, and talked, that, behold, there appeared a chariot of fire, and horses of fire, and parted them both asunder; and Elijah went up by a whirlwind into heaven. And Elisha ... cried, 'My father, my father, the chariot of Israel, and the horsemen thereof.'"

II Kings 2:11–12

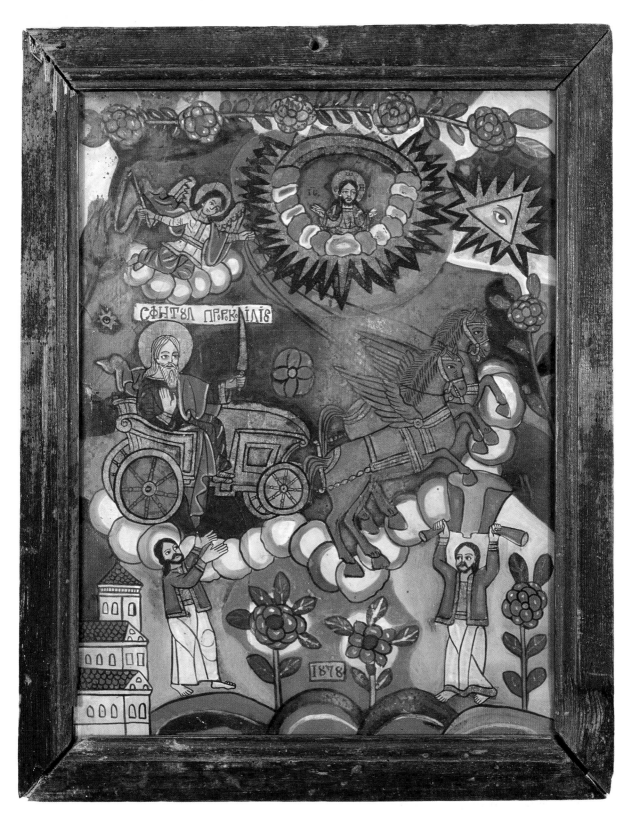

To stay informed about upcoming TASCHEN titles, please request our magazine at www.taschen.com/magazine or write to TASCHEN America, 6671 Sunset Boulevard, Suite 1508, USA-Los Angeles, CA 90028, contact-us@taschen.com, Fax: +1-323-463.4442. We will be happy to send you a free copy of our magazine which is filled with information about all of our books.

© 2008 TASCHEN GmbH
Hohenzollernring 53, D–50672 Köln
www.taschen.com

Project coordination: Ute Kieseyer, Cologne
Editorial coordination and Typesetting: Daniela Kumor, Cologne
Translation: Michael Scuffil, Leverkusen
Production: Tina Ciborowius, Cologne
Design: Sense/Net, Andy Disl and Birgit Reber, Cologne

Printed in Germany
ISBN: 978-3-8228-5478-5

Photo credits:
The publisher wishes to thank the museums, private collections, archives, galleries and photographers who granted permission to reproduce works and gave support in the making of the book. In addition to the collections and museums named in the picture captions, we wish to credit the following:

All images of the Ikonen-Museum in Recklinghausen:
© Ikonen-Museum, Recklinghausen

© akg-images/Cameraphoto: p. 21; akg-images/Hervé Champollion: p. 32; akg-images/Erich Lessing: p. 18 left
© Bildarchiv Preußischer Kulturbesitz (bpk)/Ägyptisches Museum und Papyrussammlung, SMB/Georg Niedermeiser: p. 11; bpk/Kupferstichkabinett, SMB/Volker-H. Schneider: p. 20
© The Bridgeman Art Library, London: p. 8
© The Trustees of the British Museum, London: p. 15
© Eva Haustein-Bartsch: p. 7
© Museum am Ostwall, Dortmund: p. 25
© 1990 Photo Scala, Florence: pp. 2, 10 right, 19, 22 left, 22 right, 23, 38, 52, 78; 2008 Photo Scala, Florence/DeAgostini Picture Library: pp. 16–17
© Tretyakov Gallery, Moscow: p. 24
© for the work of Alexei von Jawlensky: VG Bild-Kunst, Bonn 2008: p. 25

Reference pictures:
p. 30: Russia, *Epitaphios (Plascanica)*, c. 1600. Embroidery made of silk threads, chryssonima, gold and silver wires on silk underlaid with linen and sewn together from five pieces, 83 x 113 cm. Recklinghausen, Ikonen-Museum
p. 32: Andreas Ritzos (?), *Royal Door*, 2nd half of 15th century. Egg tempera on wood, 165 x 72.5 cm. Patmos, Hagios Georgios Aporthianon
p. 38: Filippo Lippi, *Imago Pietatis* (detail), c. 1430. Tempera on wood, 22 x 15 cm. Florence, Museo Horne
p. 40: Northern Russia, *Nicholas rescues seafarers in distress*. Detail of *Nicholas with Scenes from his Life*, late 15th century. Egg tempera on wood, 92.5 x 71 cm. Recklinghausen, Ikonen-Museum
p. 42: Russia (Novgorod), *Presentation of Christ in the Temple*, late 15th century. Egg tempera on wood, 47.8 x 36.2 cm. Recklinghausen, Ikonen-Museum
p. 44: Nikolaos Tzafoures, *Madre della Consolazione,* before 1500. Tempera on canvas and oak, 73 x 55.3 cm. Private collection (since 2001 on permanent loan to the Ikonen-Museum Recklinghausen)
p. 52: Russia (Novgorod), *St George and the Dragon, with Scenes from the Saint's Life,* 1st half of 14th century. Egg tempera on wood, 90 x 63 cm. St Petersburg, State Russian Museum
p. 60: Inscription on the reverse of the Mandylion, 2nd quarter of 16th century. Recklinghausen, Ikonen-Museum
p. 62: Russia (Onega Region), *Christ "The Never-sleeping Eye"*, detail of an arch over the Royal Door of an iconostasis, 1st half of 17th century. Egg tempera on wood, 55.3 x 102.1 cm. Recklinghausen, Ikonen-Museum
p. 78: *Philoxenia of Abraham* (detail), 546/547. Mosaic. Ravenna, San Vitale
p. 92: Russia (Guslitsa), *Great Patriarch Crucifix*, 19th century. Bronze with white and blue enamel, 39.7 x 25 cm. Recklinghausen, Ikonen-Museum

Page 1
RUSSIA (MOSCOW)

St Nicholas
3rd quarter of 16th century, egg tempera on wood, 28 x 22.3 cm
Recklinghausen, Ikonen-Museum

Page 2
ANDREY RUBLEV

Holy Trinity
c. 1411, egg tempera on wood, 142 x 114 cm
Moscow, Tretyakov Gallery

Page 4
GREECE (CRETE)

Transfiguration of Christ (detail)
mid 16th century, egg tempera on wood, 76.5 x 51 cm
Recklinghausen, Ikonen-Museum